ART AND RITUALS
2500 YEARS OF JAINISM IN INDIA

Art and Rituals
2500 Years of Jainism in India

EBERHARD FISCHER
&
JYOTINDRA JAIN

STERLING PUBLISHERS PRIVATE LIMITED
NEW DELHI-110016

Distributed in the USA by
International Publications Service, Inc.,
114 East 32nd Street, New York; N.Y. 10016

ISBN 0 8002 0178 7

Art and Rituals
2500 Years of Jainism in India

© 1977, Eberhard Fischer & Jyotindra Jain
(Translated from German by Jutta Jain-Neubauer
Published by S.K. Ghai, Managing Director, Sterling Publishers Pvt. Ltd.,
AB/9, Safdarjang Enclave New Delhi-110016.
Printed at Sterling Printers, L-11 Green Park Extn., New Delhi-110016

Preface

'...the most northerly caves of Ellora, occupied by the sitting and standing figures, are the works of Juttees, who by the brahmins are esteemed schismatic; and whose sect, called Shawuk, is very numerous in Guzerat. The tenets, observances, and the habits of the Shawuks are peculiar and, in many points, very different from other Hindoos. Their adoration of the deity is conveyed through the mediation of Adnaut and Parisnaut, the visible objects of their worship, personified as a naked man, sitting or standing.'

<div align="right">SIR CHARLES MALET'S ACCOUNT OF ELLORA—1798</div>

The present book was first published in German as an introduction to a large exhibition on Jaina Art and Culture held in Zurich, Switzerland, in 1974 to mark 2500 years of *nirvana* of Mahavira. The main purpose here is to deviate from the usual path of showing isolated religious objects and instead to understand with the help of most extensive documentation and information the art in the context of its culture. We wanted to provide a more detailed picture of some of the lesser known aspects of the art and culture of Jainism. For this reason we visited the craftsmen who are the traditional makers of the jaina images, we documented the techniques and principles of their work, we prepared the first elaborate account of the ceremony of idol-installation in a jaina temple, we travelled thousands of kilometres in India to record the household life of the Jainas, the temple rituals, the festivals, processions, pilgrimage etc. For days together we accompanied monks and nuns to observe their daily routine and to understand their world-view.

For completion of this work we are thankful to many institutions and individuals for their charitable contributions. Our foremost thanks are due to the Volkart Foundation, Winterthur/ Bombay who gave a scholarship to Dr. Jyotindra Jain to work on the project. We express our gratitude to' Muni Sri Vidyanand, to Sri Kasturbhai Lalbhai, Ahmedabad, to Sri Shreyansprasad Jain, N.C. Jhaveri and Sri V.K. Dharamsey, Bombay, for their valuable guidance and help, and to the Museum fur Indische Kunst, Berlin, for some of the photographs of the objects respectively mentioned in the captions to the illustrations. In our various tours we received warm hospitality from Seth Sir Bhagchand Soni in Ajmer, from Kamal and Anjali Mangaldas and from Gira Sarabhai in Ahmedabad, from Dr. and Mrs. N.N. Berry in New Delhi, from Sri R.C. Shah and Jyotsna Milan in Bhopal and from Prof. S.P. Varma in Jaipur.

All the photographs in the book are by the authors, if not mentioned otherwise.

<div align="right">E. FISCHER/J. JAIN</div>

Zurich/Ahmedabad, July 1976

Contents

Bibliography

ORIGINAL WORKS

Adipurana of Jinasena. Benaras, 1963.

Kalpasutra. transl. Jacobi, H., "Sacred books of the east," vol. XXII, repr. Delhi 1964.

Trisastisalakapurusacaritra. (Tri) vols. I to VI, transl. A. Johnson. Gaekwad Oriental Series, Baroda, 1931 to 1964.

SECONDARY WORKS

Bruhn, K., *The Jina Images of Deogarh.* Leiden, 1969.

Deo, S.B., *History of Jaina Monachism.* Poona.

Glasenapp, H. von, *Der Jainismus.* Berlin, 1925.

Kirfel, W., *Kosmographie der Inder.* Bonn-Leipzig, 1920.

Lohuizen-de Leeuw, J.E. van, *Indische Skulpturen der Sammlung von der Heydt.* beschreibender Katalog. Zurich, 1964.

Moeller, V., *Symbolik des Hinduismus und des Jainismus.* Tafelband, Stuttgart, 1974.

Moti Chandra, *Jaina Miniature Painting from Western India.* Ahmedabad, 1949.

Shah, U.P., *Studies in Jaina Art.* Banaras, 1955.

Sangave, V.A., *Jaina Community : A social survey.* Bombay, 1959.

Williams, R., *Jaina Yoga.* London, 1963.

Introduction

Jainism is one of the ancient religions of India. One presumes that it already existed in similar form as of today in the 6th century B.C. Most probably, it was propounded by Parsvanatha and was reformed and built into a closed system by Vardhamana Mahavira, a contemporary of Gautama Buddha. Today, there are about 2.6 million Jainas in India which is 0.47 per cent of the total population of the country (1971 census). Though the Jainas are spread all over India, their main concentrations are in Gujarat, Karnataka, Madhya Pradesh, Maharashtra and Rajasthan.

Jaina, as the followers of the religion call themselves, is derived from the Sanskrit word *jina*, 'conqueror', a title attached to revered Beings of this religion who have conquered the world of passions by their own strenuous efforts; in other words, who have obtained perfect knowledge and absolute freedom from the bondage of *karma*. It specially refers to the *tirthankara*, the one who has built a passage through the ocean of births, meaning the teachers of this religion. Sometimes, *tirthankara* is also understood to mean the founder of the four *tirthas* or the orders of the monks, the nuns, the male lay-followers and the female lay-followers. Jainas believe that there were 24 such *tirthankaras* of which Rsabhanatha or Adinatha was the first, who is supposed to have lived in the mythical past, and Mahavira the last who lived 2,500 years ago. Historically, only the existence of Mahavira is traceable and that of Parsvanatha may be inferred. Mahavira was born under the name of Vardhamana as the son of Siddhartha, a local chief of Vaisali, in modern Bihar. As a child he displayed special qualities of body and mind and, therefore, earned for himself the title of Mahavira, the great hero. At a young age he renounced the world and wandered around as a naked monk and attained *kevalajnana* the highest enlightenment, when he was 42. Thereafter he went about the country as an enlightened preacher and gave a new struc-

ture to the order of monks and won for himself innumerable lay-followers. Mahavira's path was that of severe asceticism and detachment from worldly objects, relations and sentiments. He followed it with extreme strictness and without compromise unlike the middle path of the Buddha. At the age of 72 he breathed his last and attained *nirvana*—the final liberation.

Mahavira's teachings, somewhat like those of the Buddha, aimed at showing a way to millions of suffering beings to attain the highest and permanent happiness. Jainism and Buddhism have been described as two reform systems against Brahmanism which by the end of the 6th century had become a religion of complex polytheistic beliefs which entailed complicated sacrifices, including blood-sacrifice, offered to various deities through the help of Brahmin priests who had the highest place in the *varna* system which was, in their belief, created by God Himself. Broadly speaking, Mahavira and the Buddha denounced the institution of sacrifice, existence of God, caste-system and firmly believed that these were not only unnecessary, but were hindrances in the path of attaining happiness and liberation. The only way, according to them, to attain final emancipation from misery was through self-discipline, asceticism and meditation.

The essential teachings of Mahavira were canonised only in the 3rd century B.C. and were put in writing several centuries later. It is said that after Mahavira's death there was a famine in the region of Bihar which was the main centre of his followers. Under the leadership of Bhadrabahu, a large group of monks left Bihar and migrated to Karnataka. Sthulibhadra, another leader of the group, however, stayed back in Magadha. The former, who stuck to the strict regulation of nudity and prescribed methods of begging and eating food became known as 'Digambara', the sky-robed, and the latter who continued to live under famine conditions and changed his ways became known as 'Svetambara', white-robed.

The Svetambara Jainas are found above all in Gujarat and Rajasthan. They are divided into two sub-sects, namely, *deravasi* worshipping the idol in temple and *sthanakavasi* worshipping their teachers in a monastery. The Digambaras who live mainly in central and south India, are divided into 'Terapanthi' and 'Bisapanthi' sub-sects. They differ from each other in the observance of rituals.

The Jainas are also divided into various castes, though the rules of caste-endogamy and inter-caste relations are not very strictly followed. Within the community, the Jainas also maintain the traditional affiliation to a certain line of monks (*gaccha*). Several lineages of monks exist side by side without any order of hierarchy.

According to Jainism, the soul which possesses infinite knowledge controls actions and perceives pleasure and pain through bodily agencies. Liberation from the material body and worldly activity which are the sources of misery could be attained by destroying desire and attachment by following the path of discipline and penance. One of the basic ethical principals of Jainism is *ahimsa*, not to violate any form of life, and *aparigraha*, non-possession. In order to avoid injury to living organisms, professions such as agriculture, animal-husbandry, etc. are prohibited for the Jainas. Occupations involving less mobility such as those of merchants are more suitable to them. Due to this reason the Jainas own large business-houses connected with textiles, grains, machinery and capital investment. It is ironical that Jainas, who hold the principle of *aparigraha* in high esteem should have amassed great wealth and should have become one of the wealthiest communities in India. Cities like Ahmedabad are full of jaina merchant aristocracy who, along with Parsees, understood relatively early the importance of the textile industry and became wealthy in the years of its foundation. Other industries which are at least partly owned by Jainas are the chemical industry, the paper-industry, newspapers, precious metals, jewellery and banking. Most of the middle-class Jainas are accountants, bank-employees or petty shop-keepers; rarely labourers or craftsmen.

Historically, Jainism found patronage of early rulers like Chandragupta Maurya, Asoka, Kharavela of Kalinga, etc. With their help and suppor the religion spread outside Bihar upto Mathura, Orissa and Karnataka. In the medieval era, the rulers of Gujarat were great patrons of Jainism and it was due to them that some of the most remarkable monuments of the faith came into being. Under the patronage of Solanki rulers, Siddharaja and Kumarapala, flourished the great jaina teacher and scholar Hemachandra Acharya.

Art of the Jainas

The earliest works of art connected with the Jaina faith are the group of cave monasteries at Udayagiri and Khandagiri in Orissa (figs. 1 to 8 and 12). At Udayagiri an inscription of King Kharavela, a follower of Jainism belonging to 150 B.C., has been discovered. Outside some of these caves there are richly carved reliefs stylistically resembling the carving of Bharhut and Sanchi. Along with general scenes with warriors, charioteers, men and women, animals and vegetation, there are other recognisable motifs of the enclosed tree or elephants illustrating a goddess which are more obviously connected with Jainism and Buddhism. These monasteries were excavated by King Kharavela for the use of jaina monks. *Tirthankara* image in human form was not worshipped in this early period. A hoard of jaina antiquities found at Kankali mound, Mathura, dating from 150 B.C. to the end of the first millenium of this era provides an interesting study of evolution of jaina iconography. A few stone-tablets of homage (figs. 9,13,14,19) belonging to the 1st century B.C. indicate that Jainas worship *tirthankaras* through such symbols as *stupa*, *caitya*-trees, *dharmacakra* etc. In addition, such symbols as *srivatsa*, *svastika*, lotus bud, a pair of fish and full vase which later on crystallised in the sets of eight auspicious marks of both the sects. Along with the various symbols the earliest anthropomorphic image of the *tirthankara* also appeared on these tablets. The tablet of the wife of Sivaghosaka, assigned to the 1st century A.D., shows a figure of Parsvanatha, the 23rd *jina*, being worshipped by two naked monks flanking him (fig. 9).

These early *jinas* were depicted seated in *padmasana* with open palms, placed one over the other, resting on the lap, eyes concentrated in meditation and the hair on the head either shaven or shown as curled locks. Most of the basic features of the standard *jina* image through the centuries remain the same as in the period of its

origin. The *jina* images of the Kushana period are, as a rule, naked and are found both in *padmasana* or in *kayotsarga*, standing posture. These images though bulky are devoid of any symbol of cognition or attendant *yaksha* or *yakshi*. In most cases there is no halo behind the head (figs 15, 16, 17, 18,). Such features as the long locks of hair, hanging over the shoulders in the case of Rsabhanatha image (fig. 15) and seven-hooded snake-crown in that of Parsvanatha (fig. 11), got crystallised in this early period of jaina art. Except two *tirthankaras* the rest of the 22 are depicted without any difference in their appearance.

In the Gupta period (figs. 17, 18, 25 to 27) the jaina cult image was evolved three-dimensionally. The figures became more sophisticated and light in modelling. Other features of the images of this period include an elaborately carved halo, often approached by two flying figures of worshippers or garland-bearers, a pedestal with two lions on the sides and a wheel in the centre, two attendant *chauri*-bearers, often standing on lotus-pedestals. Some of the representative examples of this type are preserved in the Mathura and the Lucknow museums. In the post-Gupta period (figs. 29, 30, 48 to 59) the jaina pantheon, as depicted in art, was enlarged. Each *tirthankara* had a pair of his attendant *yaksha* or *yakshi*. The symbol of cognition became a regular feature. Triple umbrella over the head and figures of nine planets started to appear on the pedestal. Hundreds of images of this period have come to light from Deogarh, Chanderi, etc., in central India. Belonging to the early post-Gupta period are the remarkable examples of jaina cave temples at Badami and Ellora. Here in the most elaborately fashioned cave temples there are relief sculptures of *jinas*. In Indra Sabha at Ellora there are the popular reliefs of Parsvanatha's rescue by the serpent king and the queen and of Gommata's austerities. Meditating Parsvanatha was attacked by a demon and was rescued by a serpent king and his consort who later became his *yaksha* and *yakshi* (fig. 36). Gommata or Bahubali, the son of Rsabhanatha, renounced the world after a conflict with his brother Bharata and practised such severe austerities that creepers grew around him and snakes resided in the groves nearby (figs. 38-39). In the period between 10th and 13th centuries there is a multiple activity of temple construction (figs. 60 to 74). The temples of Svetambara faith are mainly in western India. The marble shrines at Delvada, Mt. Abu, and Kumbharia in north Gujarat are magnificent monuments of fine and intricate workmanship. At Mt. Abu the 16 *Mahavidyadevis*, the goddesses of magic, appear in full iconographic detail and so also the *yakhas-yakshis* and the guardian of directions. Of the same period and mode but somewhat lesser known examples are the Mahavira temple, Osian, and the Taranga hill temple, north Gujarat. In the same context may also be mentioned the later but exquisite shrine at Ranakpur, Rajasthan. At Palitana, Satrunjaya hill, there are temple-cities dating from medieval to modern period. At Surat and Patan in the late medieval period, many small wooden shrines were constructed, marked by intricate carving which is also common to many secular buildings of Gujarat.

Monuments of the Digambara faith from the medieval period come mainly from central India. (figs. 30 to 35). The most noteworthy examples are the jaina temples at Khajuraho, the shrines of Deogarh (Uttar Pradesh), Chanderi Gyeraspur and Gwalior in Madhya Pradesh, and the exquisite pillar of glory at Chittorgarh in Rajasthan.

Also, in southern India the Jainas created important monuments of art (figs. 38, 40, 44 to 47). In the Chalukya period several shrines were constructed at Aihole and Pattadakal of which the Meguti hill temple at Aihole is the most remarkable for its plan and for the sculpture of Mahavira's *yakshi*, Siddhaika, riding a lion. At Sittanavasal, there are remains of jaina paintings of the 9th century. In the 10th century the famous 21-m high colossus of Gommata was installed at Sravanabelagola in Karnataka. Characteristic creepers entwine the body of the majestic ascetic. On the opposite hill there are remains of monasteries, cult images, reliefs with scenes of the life of monks, etc. All south Indian monuments belong to the Digambara sect. In a later period under the Hoysala rulers, many jaina shrines such as Lakkundi were built in local style in Karnataka.

In jaina temples, along with the main image (*mulanayaka*), many smaller ritual images (*vidhinayaka*) of bronze are installed. The earliest bronze objects date from 1st century B.C. from Bihar.

Of Gupta period there are bronzes from Chausar in Bihar and from western India the superb bronzes of the so called Akota hoard. Jaina bronzes of Chola style from Sittanavasal are remarkable for refinement of modelling. Of

medieval period there are, in addition to hundreds of *jina* images, other bronze objects such as the *yantras*, the replicas of *samavasa rana* (the divine preaching hall for *tirthankara*), figures of goddesses, models of mythical mount Meru, plaques depicting auspicious symbols, etc. Most of these objects are worshipped in temples at Surat, Patan, Ahmedabad, etc., in Gujarat, Jaisalmer, Osian, Jaipur in Rajasthan and many other shrines in Madhya Pradesh and Karnataka. The bronzes provide interesting material for the study of minute differences of iconography of the Svetambara and Digambara variations as well as northern and southern types.

Jaina Libraries : manuscripts and miniatures

According to jaina historians, the scriptures of Jainas were put in writing after the 5th century. The early manuscripts were either painted or inscribed on palm leaves. Manuscripts written on paper started appearing in early 14th century (fig. 92-107). A normal jaina manuscript consists of several single oblong sheets of 26×12 cm placed inside a jacket or a cover. These covers consist of a hard back of wood or cardboard mounted with a piece of cloth which often ends in a wrapping folder. On these covers, there are either painted or embroidered depictions of the eight auspicious marks such as *svastika, srivatsa, nandyavarta*, a powder flask, a throne, a full vase, a mirror, and a pair of fish or of the 14 auspicious dreams which occurred to the mother of the *jinas* before their birth such as an elephant, a bull, a lion, the goddess Sri, a garland, the moon, the sun, a banner, a full vase, a lotus-lake, ocean of milk, a divine palace, a heap of jewels, and a smokeless fire.

Except a few examples of jaina manuscripts of the Digambaras originating in southern and central India, most of the important manuscripts come from western India and belong to the Svetambara sect. These manuscripts are for the most part in Prakrit and rarely in Rajasthani or early Gujarati and are written in Devanagari script in red or black ink on the natural background of the paper or in gold over a dark blue, black or crimson painted background. Often, there are illustrations of the scenes described in the manuscripts. Of all the revered books of the Jainas, the *Kalpasutra* is the most popular. Hundreds of illustrated manuscripts of this work are available in various libraries and private collections. The *Kalpasutra* illustrations incorporate mainly the five auspicious events of the life of Mahavira, namely, the events of conception, birth, renunciation, enlightenment and *nirvana*. These miniatures are highly stylized, belonging to the western Indian school of painting, using a prominent outline of drawing and such colours as red, blue, black and gold. The earlier works are marked by soft contours, sharp drawing and elaborate details whereas the later ones are often crude and rough. In addition to these manuscripts, there are often examples of jaina paintings from smaller places and of local styles. These later productions include many *tantric* diagrams and scenes of heaven and tortures of hell painted in semi-folk manner. The Svetambara Jainas have the tradition of presenting copies of *Kalpasutra* to the monks during the Paryusana festival. Today the printed *Kalpasutra* is presented. Some of these manuscripts are preserved in the jaina *bhandaras*, libraries of Surat, Patan, Cambay and Ahmedabad in Gujarat and Jaisalmer in Rajasthan belonging to the Svetambaras, and in Delhi, Jaipur, Mudabidri Karanja (the last two in Karnataka) belonging to the Digambaras. Mention also must be made of the handwritten and elaborately illustrated scrolls of invitation sent to the *acarya* monks inviting them to come and spend the monsoon season in the town of the host *sravakas*.

Preparation of manuscripts is not undertaken anymore. Pandit Sukhlal Gandhi, an ayurvedic practitioner at Mandsor, Malwa, who was our informant, had once acquired training in calligraphy in Indore. He said that a jaina monk gave him the recipe for black waterproof ink which was a secret in those years. His narration runs as follows : "To prepare such an ink one needs 125g lac powder, 30g *suhaga*, an ingredient also used for melting gold, 30g of lod root, 15g of gum arabicum. Boil 500g of water. Put the lac powder and *suhaga* inside and later on add the root and the gum powder. The mixture would be now light brown. For red ink a red colour powder is added to this solution, whereas for black ink the black of the lamp is mixed. The lamp-black is collected by hanging a clay plate over an oil lamp overnight." For writing, a reed pen was used, the point of which was cut at an angle by the calligrapher according to the need. Earlier, hand-made paper was pressed over a

wooden board on which a cotton thread was passed through the holes on the sides to provide light embossed markings of horizontal lines running equidistant and parallel (fig. 101). "At the beginning of this century, Chanderi in Madhya Pradesh was an important centre of manuscript copying," added the Pandit.

Marble Workers of Rajasthan

Most of the jaina temples constructed after the 10th century in northern India are of marble or at least have a marble cult image inside the shrine. Due to its hard surface it is easy to work out minute details in marble. The stone is available in spotless white blocks and is highly polishable. Owing to these qualities it is ideal for *jina* images which are regularly given ritual bath and are wiped with hard cloth and besmeared with various pastes. White marble comes from the quarries of Makrana, near Jodhpur, in the Thar desert. From the deep quarries large blocks of marble are separated by putting gun powder in the trenches. The large pieces are pulled out with the help of hand-operated cranes and are cut into regular square or oblong blocks by inserting through them iron rods in one line and chopping off the irregular sides. This is the most ancient method of cutting stone which is traditionally prevalent in India. These blocks are transported to various shops of marble workers and dealers by bullock-cart as well as by mechanised transport (fig. 110). In the case of an extremely large image, the workers come to the stone-quarries and complete the statue before it is transported. Often architectural parts are worked out at the site of the temple itself. Only the cult images are made at workshops of sculptors.

The most important centre of marble sculptors is Jaipur. In this city in a certain street there are long rows of shops employing about 500 workers. The master artisans are often Adi-Gaud Brahmins whereas many workers come from various castes of smiths, carpenters, potters, many farmer castes and Muslim groups. In many workshops, Muslim sculptors are wholly responsible for fine workmanship of jaina cult image.

The jaina images even today are made according to the proportions and iconographic details as given in the *silpa sastra* texts. They use popular editions of *silpa* books with simplified outline drawings of the front and side views of the image which are marked by several horizontal and vertical lines indicating comparative proportions of the head and the limbs (fig. 113). The basic measure of proportion is the measure of the head. The rest of the limbs are measured in terms of the head measurement and therefore the most important tools of the workers are the measuring rod and the divider (figs. 114 to 116, 123). At first the division of space is done by charcoal stick and later it is cut out by running a chisel over it. Then the proportions of the head, hands, chest, etc. are marked (fig. 112). After this the drawing of the rough outline of the figure is made. First of all, the nose which is the most protruding part is marked and chipping off the two cheek planes throws it into relief. The whole figure is worked out into various cubic planes with sharp dividing edges. The armpits and the sides of the chest are hollowed out by a large chisel and then the feet, the arms and the chest are slowly worked out (figs. 121 to 123). The areas which remain to be worked out or reworked are smeared with a red solution so that the worker can keep on comparing the already worked out white areas with the unworked red areas. In working out the whole image large flakes are removed first; then large flake markings are worked out with a smaller chisel into the planes of smaller flake markings and finally with a fine chisel the latter are worked out into smooth surfaces. The finishing is done by the master craftsman himself. He also retouches the eyes and the lips to impart the desired expression to the face. Generally, the master craftsman supervises the work at all stages. Some artisans are specially trained for decorative carvings of pillars and other architectural parts (figs. 126 to 130). A finished image is handed over to women who impart a bright polish to it (fig. 125) by rubbing it with a kind of soapstone and water for several days.

Various kinds of chisels are made by local blacksmiths from pieces of iron bars. Each worker has his own set of tools and works on image making only in the morning hours. In the afternoon the workers reshape the broken or worn out points of their chisels or sharpen tools (figs. 114 to 116, 120).

The sculptors sit in a large hall or a verandah and work on the floor. The pieces to be worked out are placed on sand mixed with marble chips and fixed with supports of pieces of stone. No

ritual is performed nor any sacred treatment is given to the half-complete image in the workshop. A worker seated over the half-complete *jina* image and smoking and chatting is a common sight. A workshop owner told us that occasionally the people who commissioned the image insist that the worker should not touch the image without first taking a bath, or should change his clothes after visiting the toilet. Some customers pay for a lamp kept lit till the image is completed.

The workers are paid on a daily basis. Compared to the other artisans the marble workers earn fairly more. A skilled worker earns about Rs 15 to 18 a day, whereas an apprentice earns about Rs 6 to 8. The sons of the shop-owners learn in their own workshop whereas others go to a small workshop run as a school by a worker.

In Jaipur as well as in many parts of southern India, bronze images of *jinas* are produced. These are made by cire-perdue technique in which a wax image is prepared and is covered with a coating of clay. When it dries up it is heated up so that the melted wax runs out and molten metal is poured inside. Finally the clay-coating is broken to take out the metal. This metal image is then worked out with chisel and files and polished in the end.

Jaina Temples : centres of rituals

Though the Jainas do not worship any transcendental God and are supposed to be atheistic, they have constructed magnificent temples and have evolved a complex set of rituals. Purifying the soul through meditation and asceticism, trying to put an end to all misery and attaining the highest liberation or *nirvana* is the aim of all human existence. This goal has been attained by the *tirthankaras*. To meditate on this Being and his qualities in order to advance on the path of purification of the soul and attainment of *nirvana*, Jainas visit temples where the images of such tirthankaras are installed. Jainas do not worship gods to seek their grace for material prosperity. Their temples are administered by foundations consisting of members known for their patronising-religious activity. Some jaina temples belong to the Svetambara sect (figs. 132, 136, 138 to 148) and others to the Digambaras (figs. 133, 135, 137). Some are patronised by a certain jaina caste or

regional group but all temples are open for worship to all members of the community. Large jaina foundations have established and run eating halls (fig. 156), resthouses, schools, libraries (fig. 104), colleges, research institutions, publishing houses, students, hostels, veterinary hospitals, etc. Many temples own precious jewellery, silver chariots and other expensive objects used for worship and rituals.

It is worth mentioning that ceremonies in most north Indian jaina temples are conducted by Brahmin priests. Mostly they come from Rajasthan. They receive a fixed salary for performing services in a jaina temple though at home they are vaishnavite Hindus. This situation is understandable in view of the historical development of jaina belief and practices but still the fact as such is interesting. One should try to imagine European Christians employing Jewish Rabbis to conduct church service. Most of the jaina temples employ watchmen who are generally non-Jainas. At the entrance the visitors have to remove their shoes. Often temples have their own source of water needed for daily bath of the image as well as for the bath of participants. The cult image is installed in the inner chamber of the temple. This chamber is secluded from the outer hall by a surrounding wall and a door which can be locked. In the outer hall, in front of the inner chamber, normally another small shrine is set up (figs. 142, 143) in which a small ritual image is placed. In front of this installation there are tables over which offerings like rice-grains, fruits, etc., are placed (fig. 141). The structure of the inner chamber is separated from the surrounding walls by empty space which is used as a circumbulatory path. Some large temples even have two worship halls and shrines, one for daily worship by men and another for women. In many Svetambara temples, musical instruments are kept for ritual use (fig. 144). One corner is reserved for preparation of sandalwood paste used in daily ritual. All Jainas put a sandal paste mark on their forehead on their visit to the temple. Apart from the main cult image, each jaina temple has several smaller shrines of other *jinas* in the surrounding chambers. On the pillars, walls, ceilings, etc., are often paintings of gods, goddesses and places of pilgrimage. In a corner there is usually a small shrine of *ksetrapala*, a guardian deity who is also very popular in village cults.

Daily Ritual

Early in the morning the Brahmin priest begins to clean and prepare the images for their daily bath. The lay worshippers come to the temple after taking a bath and wearing fresh clothes. Most of the regular visitors do not eat anything before coming to the temple. Some orthodox worshippers, when they are not able to visit the temple due to illness or some other reason, observe a full or a partial fast as repentance.

After removing the offerings of the previous day and after dusting the images, the *pujari* (priest) washes them and puts fresh flowers and applies sandalwood paste. In the outer hall the lay-worshippers start the ritual by giving a bath to the image which is a kind of reminiscence of the post-birth illustration of Mahavira by Indra. While giving the bath the worshippers also sing devotional songs, apply sandalwood paste dots, offer flowers and rice-grains. The water and other liquids by which the image is bathed are collected in a large vessel which is placed in a corner. All visitors dip their fingers in this water and apply it to their forehead and eyes. Those worshippers, who do not take part in the bathing ritual, worship the image with folded palm, greet by kneeling in front of the image and offer rice-grains, cloves, almonds, flowers or fruits. Often, the visitors make from rice-grains the diagrams of *svastika*, *nandyavarta*, the moon and the dot of the sacred syllables Om and Hrim. In some Svetambara temples, some worshippers hold a lamp in front of the image or worship the reflection of the image in the mirror (figs. 139, 140).

In the afternoon the temple is closed but occasionally there are special sermons by a monk or a nun. In the evening the temple opens again. In Digambara temples, the evening ritual consists of a simple prayer sung in front of lamps. In Svetambara temples, the image is decked with heaps of flowers or jewels or thin silver sheets. At close, the *arati* ceremony takes place in which many lamps are lit and moved in front of the image accompanied by devotional songs. (fig.138).

Jaina Festivals

Paryusana or Daslasksana Parva

This festival is celebrated by both Svetambara as well as Digambara Jainas for eight to ten days during the monsoon season. This is a festival of self-discipline through fasting and other ascetic practices. Men, women and children as well as monks and nuns undertake fasts with varying strictness. While some observe fast on all the eight days, many fast on alternate days but all fast on the last day. During Paryusana, there are regular sermons and ceremonies in the temples. In Digambara temples, chapters from *Tattvartha Sutra*, the Bible of the Jainas, and in Svetambara temple those from *Kalpasutra* are read out to the audience. On the last day, members of the community greet each other and ask forgiveness for any pain that might have been caused knowingly or unknowingly by any of their actions during the past year. Those members of the community who undertake complete fast during the festival days are taken to the temple in a procession on the last day after which they break the fast. The Jainas are specially zealous during Paryusana to prevent any animal life being taken. Often jaina foundations pay money to close down slaughter houses to save animal life during the festival days.

During the festival days, the Svetambara Jainas drink boiled water at home and abstain from eating or drinking in a restaurant or in the houses of non-Jainas. After a bath and change of clothes people go to the temple. Those who do not fast come back home after worship for lunch and those who fast remain in the temple the whole day meditating or participating in the reading of scriptures or religious discourses. During Paryusana, the Svetambaras also take out a copy of *Kalpasutra* in procession. A young girl after worship in the temple carries the *Kalpasutra* in a large metal plate over her head in a procession (figs. 145, 146). A man walks in front of the girl, sprinkling water from a pot on the street, symbolically cleaning the city. The scripture is brought to the house of a wealthy Jaina who makes a donation to a temple. There the holy book is installed on a high pedestal and worshipped the whole night to the accompaniment of devotional songs. The next day it is brought back to the temple in a procession. On the fifth day of the festival, a skylight is opened in the ceiling and silver replicas of the dream images seen by the mother of Mahavira are lowered on a string to the crowd gathered below. On the eighth day a copy of *Barsasutra* is presented to a monk or a nun who reads it out to the people with such rapidity

that the whole text is finished in half an hour. The worshippers hold a page of the *Sutra* in their hands for a few seconds and place it back, symbolising the reading of the text themselves.

Akshayatritiya

This festival is observed in April, and is celebrated mainly by the Svetambara Jainas. On this day sugarcane juice is ritually offered to those who have observed various types of fasts throughout the year. According to jaina literature, on this day Rsabhanatha, the first *tirthankara*, received in accordance with the religious ritual food in the form of sugar-cane juice for the first time after his continuous fast of six months from the hands of the mythical Prince Sreyamskumar. The ladies who participate in the ritual are given garlands and are brought to the temple in a small procession (figs. 149 to 154). The relatives of the participants go to a nearby shop of sugar-cane crusher, wash the press with boiled water and collect the juice in earthen pots. They bring the juice to the temple and offer to the participants 108 small cups full of juice. After observing this ritual the participants normally take a vow that for the rest of their lives they will not drink unboiled water.

Kartik Purnima

By the full moon day of *Kartik* (around November), *Kartik Purnima*, the monks and nuns start to wander further after having stayed at one place for the rainy period. On this day the monks are taken out of the town in a procession and a few people even accompany the monks to the next town or village. The community starts eating green vegetables which is not done during the rainy season. On this day many people start on a pilgrimage to Palitana. In many temples a stone panel or cloth painting of Palitana is displayed and those who cannot undertake the pilgrimage to Palitana go and worship the panel in a temple.

Divali

Along with Hindus the Jainas also celebrate the festival of Divali. For the Jainas, Divali is an important festival, because on this day Mahavira is supposed to have attained *nirvana*. In many temples of Digambara sect sweet balls are offered. Divali is also important for Jainas as it marks the beginning of their new year. All business accounts of the previous year are settled and new account books are started (fig. 161). On this day businessmen go to shops and buy new account books and worship them along with the image of Lakshmi as well as currency notes, jewellery, etc. at a special ceremony.

Mahavira Jayanti

This festival, connected with the great auspicious event of the birth of Lord Mahavira is celebrated with great pomp and enthusiasm by all Jainas. Processions are taken out, meetings are held and the message of Mahavira is explained to all.

Siddhacakra or Navadevata Puja

Siddhacakra or *Navadevata* diagram (the circle of the Siddha, the omniscient one) consists of a stylised lotus with eight petals. In the centre and in four petals of the lotus are depictions of the five highest Beings of the Jainas, namely *Arhat*, the enlightened one, *Siddha*, the liberated one, *Acharya*, the head monk, *Upadhyaya*, the teacher monk, and *Sadhu*, the monk. In the four petals the Svetambaras inscribe the principles : right knowledge, right faith, right conduct and right penance; whereas Digambaras depict *dharmacakra*, *jina* image, *jina* temple and scriptures. Apart from worshipping this diagram in the temple or in a smaller way in the house, there is elaborate worship of the same in which many people take part and the ritual lasts for nine days (figs. 157,158). In this worship, the diagram is made on the floor from grains of various colours suitable for the great Beings. Part of the worship is a narration of the story of King Sripala who is believed to have gained miraculous benefits due to the worship of this *yantra*. Generally, the diagram is worshipped on fulfilment of a certain vow or for avoiding ill luck and furthering prosperity. Such a *puja* is generally announced by the family after the events of birth, marriage, death etc.

Daily life in a jaina house

For every Jaina, the principle of *ahimsa*, not to violate any form of life through thought, speech and action, is important and directs all his activities. The day begins by sweeping the floor softly so that insects and dust are removed unharmed. Then the water needed for the day's drinking and cooking is boiled (Svetambara) or filtered several times (Digambara).

All Jainas are vegetarians. They abstain from eating meat, fish and eggs and also do not eat roots or bulbs such as potatoes, carrots, onions, etc. because consumption of roots involves the destruction of the entire plant. During the rainy season, due to ample growth of vegetation and due to presence of more insects in the green vegetables, the Jainas abstain from eating any green vegetables. Fruits and vegetables are not eaten without cutting them open and without examining each piece separately (fig. 163). Very often vegetables are opened with hand and if possible knife is not used so that no insects are killed in the process. Generally, orthodox Jainas avoid eating fresh vegetables and eat dried vegetables or grain products and pulses. Several times a month they observe full or partial fast. Alcohol, tobacco and honey are also prohibited for Jainas. Orthodox Jainas do not eat anything after sunset and some do not even drink water so that no insects, not even by chance, are consumed in the dark. Since light attracts insects, both in jaina temples and houses lights are not kept burning till late.

Self-discipline and asceticism are also directive principles for a householder. A true Jaina is expected to meditate for 48 minutes in the morning with or without help of the rosary. He is also expected to visit the temple twice daily, once in the morning and again at night. In their effort to acquire control over the body and its pleasures, they often fast or eat food without salt, spices or oil, or observe silence for hours.

Idol Installation in a jaina temple

Even today several new jaina temples are being constructed. As seen earlier, the cult images are made for installation in new temples. An image, unless it undergoes the ceremony of installation through a series of rituals, is not qualified for worship in a jaina temple. The ceremony, as observed at present, seems to be a combination of the traditional and the modern. Here we shall confine ourselves to the description of a ceremony of idol installation that took place in a Digambara temple at Songarh, Saurashtra, in 1974 (figs. 165 to 213). The ceremony consisted of three days of general worship of the five great Beings of Jainism, and rituals connected with auspicious beginning and fertility rite, and five days of ritual and theatrical depiction of five great events of the life of Mahavira. This ceremony depicting the five events of conception, birth, renunciation, enlightenment and *nirvana* is called *Pancakalyanaka Pratistha Mahotsava*, the great celebration of installation through the five auspicious events. The large main image to be installed (*mulanayaka*) was too big to be moved or taken out in a procession and therefore a small bronze image (*vidhinayaka*) was used for the ritual purposes.

At first *puja* was offered to the five great Beings, namely *Arhat*, *Siddha*, *Acharya*, *Upadhyaya* and *Sadhu* and their qualities. These Beings and their qualities were depicted in the form of a large diagram painted on the floor (figs. 171-173). On the first day the *jina* image was taken out in procession; on the second day the people who were going to play the roles of the father of the *jina* and the Indras were appointed and worshipped (fig. 174). Afterwards, a patch on the ground was selected and cleaned. On this patch, boundaries were marked by lines drawn with red and white powder and inside a square border a *svastika* was drawn and worshipped (figs. 177 to 180). Later, the ritual participants dressed as Indras and Indranis came one after the other and dug out clay from the worshipped patch. This clay was filled in eight earthen pots which were placed in eight sections of a lotus-shaped diagram painted on the floor. Near each pot a silver replica of one of the eight auspicious marks was placed (figs. 182, 183). In these pots five different kinds of grains were sown (fig. 183). The ritual was called *Mrtikanayana* (bringing of the clay), and *Ankuraropana* (sowing of the seeds). This ancient fertility ritual was interpreted by the pandit, the conductor of the ritual, as representing the increase in wealth and fertility on earth before the birth of the *tirthankara*.

After these preparatory rituals began the actual ceremony of the five events. For the event

of conception, a glass casket was installed on the stage. Inside the casket a *yantra* was placed by the man who acted as the father of the *tirthankara*. The woman acting as the mother touched the *yantra* with her fingers (fig. 186). Then the father gave a bath to the image and placed it inside the glass casket and closed it (fig. 187). The glass casket now represented the womb of the mother of the *jina*. The image inside represented the embryo and the whole event was representative of Mahavira's coming into the womb of his mother. The large marble image as well as other smaller ones were wrapped in a white cloth to indicate that these were in the embryo stage (fig. 191). At night, in a theatrical scene, the mother of Mahavira played by a lady dressed as a queen, was shown lying on a couch attended by girls dressed as heavenly maidens. She was shown, one after the other, the 16 dream images painted on a cardboard. On the same afternoon, as part of the ceremony of cleaning various parts of the temple, walls, floor, the tower and the pillars, were sprinkled with water. The large tower of the temple was caught as a reflection in a large mirror and this reflected image was given a bath on the mirror itself (fig. 196).

On the fifth day took place the event of the birth of the *jina*. The ritual image was taken out of the glass casket and handed over to the couple who acted as Indra and Indrani. They placed it on a decorated elephant (fig. 193) and brought it in a procession to an artificial tower which represented the mythical mount Sumeru (fig. 194). The image was placed on top of the tower, post-birth bath was given to it by people representing Indra and other gods (fig. 195). Later, the image was brought back and placed inside a cradle surrounded by various toys (fig. 199). On the sixth day the image was given princely clothes and was coronated on a royal chair in front of a painted theatrical curtain depicting the palace. After the ceremony of coronation, the image was placed inside a palanquin and was carried in procession outside the town. Here it was placed under a large *Asoka* tree or a platform. Around the platform an enclosure of white cloth was put up. Inside the enclosure the princely clothes were removed and some cloves were fixed on the head with sandalwood paste. Later, these cloves were scraped by the pandit indicating that Mahavira had given up clothes and had plucked out his hair to renounce the world (fig. 203). After that the pandit inscrib-

ed the letters of the alphabet on various parts of the image, showing that Mahavira had entered the path of knowledge. All this was done in the seclusion of the enclosure. Finally the image was placed inside a bucket and covered with clothes and carried away secretly by a ritual assistant (fig. 208). The last act indicated that Mahavira had disappeared in the forest and had undertaken the path of wandering alone as a monk. The image was brought back to the temple where it was installed on a high stool under a tree. On one side of the image a small peacock-feather broom and, on the other, a waterpot were placed (fig. 204). This represented the event of renunciation and monkhood of Mahavira. The next day the image, representing monkhood, was carried on the head by a devotee to the house of a layman who had invited the monk for a meal. The man stopped in front of the house where stood a couple to invite the monk for a meal (fig. 206). They had pots filled with water and covered with coconuts. The image was worshipped by the host couple by uttering the words of invitation and by circumambulating the image three times. Then the image was brought inside the compound and was placed on a high seat. In front of the image were many silver plates filled with food. The worshippers filled up spoons of food and held it in front of the image in the posture of feeding and emptied the spoons in a plate in front of it (fig. 207). The image was then brought back to the temple.

At night, again in seclusion, the pandit placed the image inside an enclosure and in front of it lit a lamp and uttered many *mantras*. This secret ritual was meant to impart knowledge to prepare for the event of enlightenment. On the morning of the next day, a jaina *guru* performed the most crucial ceremony of opening of the eyes (fig. 210). This indicated the opening of the eyes and enlightenment of Mahavira. The image was placed on top of tapering towered structure, *samavasarana*, the divine preaching hall created by the gods for the preaching of the *tirthankara* immediately after his enlightenment (fig. 209). This also represented the first sermon to the universe.

On the last day, the event of *nirvana* was commemorated. In the early morning the pandit cleaned a patch of ground, drew a *svastika* on it and placed a marble tile over it. On the tile, he constructed a miniature pyre from sandalwood pieces which he lit with a burning piece of

camphor (fig. 193). This indicated that Mahavira had attained the final liberation, *nirvana*, and that his material body was cremated. Now the image was placed inside a glass casket placed over a miniature mountain representing *siddhasila* under three umbrellas (fig. 212).

The most important part of the ritual of idol installation as practised today is the event of enlightenment represented by the act of touching the pin to the eyes to indicate the opening of the eyes. The act of opening of the eyes is also a prescription for the installation of Brahmanic images. Among the Buddhist practices followed in Sri Lanka, enlightenment is indicated by painting the eyeball as a part of the ritual.

The *tirthankara* image which had undergone the ritual of installation thus becomes qualified for worship in the temple. The ritual of opening of the eyes was also performed over the large main image (*mulanayaka*) in the temple.

Monks of the Digambara Sect

There are today less than 100 monks of the Digambara sect in the whole country. These monks are known as *muni* or *muni maharaj*. They are organised in two different *samghas* or groups which are known after the master of the group or *acarya*.

The one who wants to renounce the world on religious grounds, begins to qualify successively for the 11 basic vows. He starts to control his behaviour, to abstain from violence, to practise truth, to abstain from possession and attachment, and to live a life of a celibacy. Thus disciplined over a period of time, a person prepares for renunciation. He approaches an *acarya* or the head of a group of monks and asks his permission for *diksa*, initiation. If the candidate is a grown-up person devoid of bodily faults and has acquired the consent of his nearest relatives—parents or wife—he is given permission to renounce the world. The community gets together in a festive atmosphere. The candidate is dressed as a prince and taken out in a procession in a chariot or on an elephant (figs. 220 to 226). After that his head is shaved and he is offered the monk's attire. He is also given a new name which ends in such compounds as 'sagara', ocean; or 'ananda', joy; for example, 'santisgara', the ocean of peace, or 'vidyananda', joy of knowledge.

Among Digambaras three stages of monkhood can be distinguished. The monks of the first stage are called *ksullaka* and are permitted to wear two white clothes. Those of the second stage are *ellaka* and allowed to wear one loincloth. The monks of the final stage or the *munis* go naked. Also, different degrees of asceticism are expected during these three stages of monkhood. A *ksullaka*, for instance, is allowed to shave his head unlike the monks of the other two stages who have to pluck out the hair. A full monk eats once a day in standing posture, whereas *ksullaka* may eat twice in sitting posture.

Daily Routine of a Digambara Monk

A monk who has renounced the world is without a home and without possessions and therefore moves around completely naked. The only objects he is allowed to carry are a *kamandalu*, water-pot, and a *pichi*, a fly-whisk of peacock feathers. To practise a strict and severe ascetic life, a monk always lives in the company of other monks. Normally a monk gets up before sunrise to carry out his daily routine. In an open field he finds a clean patch of ground devoid of insects, to perform his daily necessities. After washing his hands and feet (a monk is not allowed to take a bath) he comes back to his monastic chamber where he undertakes his daily *samayika* or study of texts and sits in meditation to identify his faults such as negligence in behaviour towards living creatures. After this he goes to a nearby temple to perform *caityavandana* or worship of the *jina*. On return he goes out to beg for food. A monk keeps the thumb and the four fingers of his right hand joined together while resting on his shoulder. This is called *ahara mudra*. If he loses this posture on his way to the host-householder he is not supposed to eat on that day. This way the monk does not rest assured about the pleasure of obtaining food. A Digambara monk eats in standing posture from the hollow of his hands. The standing posture is prescribed because if a monk cannot stand anymore due to old age or illness the body is to be discarded by fasting till death. For eating or drinking he does not use any pots or pans. He eats the prescribed vegetarian food irrespective of preference. After having eaten, the monk goes back to the temple to practise *samayika* for at least 48 minutes in

order to train his mind so that neither pain nor joy may affect him. If he then does not continue his journey on the same day he stays on and his admirers, the lay-community, gather around him to listen to his preaching. Afterwards the monks read together some scriptures or enter into religious discourses.

The monks usually spend the night in a windowless cell near the temples. In summer they sleep on the 'floor', in winter on a flat wooden board, covered with straw only. In case they feel cold they help themselves with *yoga* practices which warm up the body.

A monk should wander around in the dry season. He should not get used to one place, should be without a house and without any attachment. During the four monsoon months, however, he should stay at one place together with his *acarya*, master, because at this time the growth and development of vegetation and insects are rapid. While wandering, a monk is not allowed to use any vehicle or boat. He has to walk barefoot, avoiding big streets where possible. To cross rivers he walks along the bank till he finds a ford where he is able to cross over. But the water should not be deeper than the level of the knees. Also, he is not allowed to swim.

All Digambara *munis* have to pluck out the hair four times a year. This is done mostly in front of the lay-community of the village. First, they rub ashes on their head, then they pluck out the hair in bunches. In case a *muni* is too old or too weak for this, he asks somebody to pull out his hair. Nowadays these tasks are performed by the temple administrators with great pomp. The hair is collected in cups and is auctioned to devotees for high sums. Later it is put in the river.

When a *muni* is sick, he does not eat food or drink any water. Devotees surrounding him sing devotional songs in loud chorus. After his death the body is placed in a sitting posture in a wooden palanquin named *chakdol*. It is then taken around in a procession and cremated on a sandalwood pyre. According to old scriptures, however, the dead body of a *muni* should be put on a river-bank so that it is either washed away by the river or eaten by birds.

Monks and Nuns of the Svetambara sect

The Svetambara sect is divided into a number of sub-divisions, called *gaccha*, which is a community of monks. The various communities are known after their *acarya*, the master. Such an order of monks and nuns is called *samgha* or *samudya* and is again divided into various *parivars*, i.e., families. The head of each such family is a senior monk or nun. It is advised that the monks and nuns do not move in isolation and therefore the smallest group should at least consist of two monks or three nuns who observe, control and criticize each other. All monks keep a diary in which they note down all wrong thoughts, expressions and actions, like accidental killing of small creatures, sitting under electric lights, etc. Such a diary is sent at the beginning of the monsoon to the *acarya*, who in accordance with the nature of the faults, prescribes penances of various degrees. Seniority of monkhood rather than seniority of age is the criterion for a higher position in the order.

Svetambara monks and nuns, known as *sadhu* and *sadhvi*, wear two white cotton clothes as garments. In addition, they are allowed to use various large wooden pots with strings while begging for food, and also to keep waterpots in their monasteries and to possess a long stick, four different kinds of flywhisks, a small woollen carpet, a thick and a thin shoulder cloth, a cloth to filter water and another one as mouthpiece. They also carry ritual objects, manuscripts, books and writing paraphernalia. Monks and nuns live on food-begging and are not allowed to light a fire and cook food. It is also prohibited for them to take a bath and they are supposed to pluck out their hair twice a year.

DAILY ROUTINE OF SVETAMBARA NUNS, MONKS

In order to sustain the five most important principles, the daily routine of a monk is strictly disciplined through *anuvratas* (vows) which incorporate : not to violate any form of life, not to speak untruth, not to steal, not to possess anything, and to practise celibacy.

As observed in a monastery in Surat, the nuns wake up shortly after 4 o'clock in the morning, wash themselves, say their prayers facing the east or north for 25 breathings, and repent for sins committed during the night. Then they greet their leader who tells them to put the bed in order, remove the dust in the room and to pick

up creatures tenderly with one small fan of peacock feather. Then the *namokara mantra* the daily prayer of the Jaina, is said, after which the leader is venerated. The latter in turn greets her teacher installed as *sthapana*, cross-stand. The nuns greet their superior one after the other. After that each nun decides which vow of the day she will keep; for example, to eat food without salt or sugar; not to speak during the day, not to drink anything, etc. The younger nuns once again turn towards their leader and vow that except the natural motion of the eyelids, they would not undertake any activity without her consent. Then they all go to the temple to worship the *jina*. On returning to the monastery or sleeping chambers the nuns repent for all the possible sins; for instance any creature unintentionally killed on the way or wrong thoughts coming to the mind. Then the head-nun allows them to go out to beg for food. But nuns and monks are allowed to beg only in places where there are no pregnant women and no beggars, where no dogs run about, where only strained water is used, and where food is not cooked specially for them. In most cases the nuns eat together from their pots after returning to the monastery. No food is wasted, even the water with which the lacquered wooden pots are cleaned has to be drunk.

After the meal, the nuns may wash their clothes, write letters, read religious books, speak to guests or embroider the *pato*, the cloth with auspicious symbols. About 3 o'clock in the afternoon the bed is again made, dust is removed, insects are collected carefully and removed, and prayers are said. At 4.30 they go out once again to beg for food, for they must eat their evening meal before sunset, as after that they are not allowed to eat or drink anything. After this meal, nuns visit the temple a second time to repent for bad deeds and take a vow that till the next day they will not move beyond 100 steps in any direction.

Monks as well as nuns often go on a pilgrimage, i.e. they travel to important holy places, where they lodge in *upasrayas* (temples). During the monsoon months, they are supposed to stay in one place. For this they are helped by the community which invites them formally through beautifully painted long invitation scrolls.

A large number of the Svetambara monks and nuns, even after fulfilling these daily rites, find enough leisure time to write important philosophical, historical and poetic works.

To become a Svetambara monk an aspirant has to be at least eight years old and has to have the consent of his parents for doing so. In addition he should not have any bodily defects, should not be in debt or facing a trial, etc. But it is not necessary, however, that he belongs to a jaina family. The person wanting to take *diksa* (renunciation), should get the company of monks or nuns and should live during this time the life of a *brahmacarya* (maintain sexual purity). Young people first go through a preliminary of the actual monk-consecration, which is strengthened later on. The initiate keeps complete fast to prepare himself for the ceremony. He is dressed in beautiful garments and ornaments and is taken out in a chariot or on elephant in procession in which the whole community joins. The initiate may throw coins in all directions in a symbolic gesture indicating ritually the distribution of his wealth. Then his *acharya*, master, plucks out the hair on his head. The initiate is given the monk's robe and a new name which for monks always ends in 'Suri' or 'Vijaya' and he lives in one of the monks' groups. He visits his former family the next day to beg for his first meal.

When monks and nuns have reached the age where their physical existence becomes a burden, they slowly renounce food, i.e., consciously fast till death which is called *Samlekhana*. During this period the dying monk is surrounded by members of the community who observe him constantly, but refuse to give him any food or water and make clear to him how useless his longings are, as his soul now finally will leave the decaying body. The dead body is dressed in fresh clothes and is tied on a bier and carried in a large procession through the streets with great pomp and joy. The dead body is put down in the evening in a crescent-shaped wooden boat and burnt with large quantities of ghee. It is said that the monk has crossed the ocean of life.

PLATES

PLATES

Daily life in a jaina house

For every Jaina, the principle of *ahimsa*, not to violate any form of life through thought, speech and action, is important and directs all his activities. The day begins by sweeping the floor softly so that insects and dust are removed unharmed. Then the water needed for the day's drinking and cooking is boiled (Svetambara) or filtered several times (Digambara).

All Jainas are vegetarians. They abstain from eating meat, fish and eggs and also do not eat roots or bulbs such as potatoes, carrots, onions, etc. because consumption of roots involves the destruction of the entire plant. During the rainy season, due to ample growth of vegetation and due to presence of more insects in the green vegetables, the Jainas abstain from eating any green vegetables. Fruits and vegetables are not eaten without cutting them open and without examining each piece separately (fig. 163). Very often vegetables are opened with hand and if possible knife is not used so that no insects are killed in the process. Generally, orthodox Jainas avoid eating fresh vegetables and eat dried vegetables or grain products and pulses. Several times a month they observe full or partial fast. Alcohol, tobacco and honey are also prohibited for Jainas. Orthodox Jainas do not eat anything after sunset and some do not even drink water so that no insects, not even by chance, are consumed in the dark. Since light attracts insects, both in jaina temples and houses lights are not kept burning till late.

Self-discipline and asceticism are also directive principles for a householder. A true Jaina is expected to meditate for 48 minutes in the morning with or without help of the rosary. He is also expected to visit the temple twice daily, once in the morning and again at night. In their effort to acquire control over the body and its pleasures, they often fast or eat food without salt, spices or oil, or observe silence for hours.

Idol Installation in a jaina temple

Even today several new jaina temples are being constructed. As seen earlier, the cult images are made for installation in new temples. An image, unless it undergoes the ceremony of installation through a series of rituals, is not qualified for worship in a jaina temple. The ceremony, as observed at present, seems to be a combination of the traditional and the modern. Here we shall confine ourselves to the description of a ceremony of idol installation that took place in a Digambara temple at Songarh, Saurashtra, in 1974 (figs. 165 to 213). The ceremony consisted of three days of general worship of the five great Beings of Jainism, and rituals connected with auspicious beginning and fertility rite, and five days of ritual and theatrical depiction of five great events of the life of Mahavira. This ceremony depicting the five events of conception, birth, renunciation, enlightenment and *nirvana* is called *Pancakalyanaka Pratistha Mahotsava*, the great celebration of installation through the five auspicious events. The large main image to be installed (*mulanayaka*) was too big to be moved or taken out in a procession and therefore a small bronze image (*vidhinayaka*) was used for the ritual purposes.

At first *puja* was offered to the five great Beings, namely *Arhat*, *Siddha*, *Acharya*, *Upadhyaya* and *Sadhu* and their qualities. These Beings and their qualities were depicted in the form of a large diagram painted on the floor (figs. 171-173). On the first day the *jina* image was taken out in procession; on the second day the people who were going to play the roles of the father of the *jina* and the Indras were appointed and worshipped (fig. 174). Afterwards, a patch on the ground was selected and cleaned. On this patch, boundaries were marked by lines drawn with red and white powder and inside a square border a *svastika* was drawn and worshipped (figs. 177 to 180). Later, the ritual participants dressed as Indras and Indranis came one after the other and dug out clay from the worshipped patch. This clay was filled in eight earthen pots which were placed in eight sections of a lotus-shaped diagram painted on the floor. Near each pot a silver replica of one of the eight auspicious marks was placed (figs. 182, 183). In these pots five different kinds of grains were sown (fig. 183). The ritual was called *Mrtikanayana* (bringing of the clay), and *Ankuraropana* (sowing of the seeds). This ancient fertility ritual was interpreted by the pandit, the conductor of the ritual, as representing the increase in wealth and fertility on earth before the birth of the *tirthankara*.

After these preparatory rituals began the actual ceremony of the five events. For the event

of conception, a glass casket was installed on the stage. Inside the casket a *yantra* was placed by the man who acted as the father of the *tirthankara*. The woman acting as the mother touched the *yantra* with her fingers (fig. 186). Then the father gave a bath to the image and placed it inside the glass casket and closed it (fig. 187). The glass casket now represented the womb of the mother of the *jina*. The image inside represented the embryo and the whole event was representative of Mahavira's coming into the womb of his mother. The large marble image as well as other smaller ones were wrapped in a white cloth to indicate that these were in the embryo stage (fig. 191). At night, in a theatrical scene, the mother of Mahavira played by a lady dressed as a queen, was shown lying on a couch attended by girls dressed as heavenly maidens. She was shown, one after the other, the 16 dream images painted on a cardboard. On the same afternoon, as part of the ceremony of cleaning various parts of the temple, walls, floor, the tower and the pillars, were sprinkled with water. The large tower of the temple was caught as a reflection in a large mirror and this reflected image was given a bath on the mirror itself (fig. 196).

On the fifth day took place the event of the birth of the *jina*. The ritual image was taken out of the glass casket and handed over to the couple who acted as Indra and Indrani. They placed it on a decorated elephant (fig. 193) and brought it in a procession to an artificial tower which represented the mythical mount Sumeru (fig. 194). The image was placed on top of the tower, post-birth bath was given to it by people representing Indra and other gods (fig. 195). Later, the image was brought back and placed inside a cradle surrounded by various toys (fig. 199). On the sixth day the image was given princely clothes and was coronated on a royal chair in front of a painted theatrical curtain depicting the palace. After the ceremony of coronation, the image was placed inside a palanquin and was carried in procession outside the town. Here it was placed under a large *Asoka* tree or a platform. Around the platform an enclosure of white cloth was put up. Inside the enclosure the princely clothes were removed and some cloves were fixed on the head with sandalwood paste. Later, these cloves were scraped by the pandit indicating that Mahavira had given up clothes and had plucked out his hair to renounce the world (fig. 203). After that the pandit inscrib-

ed the letters of the alphabet on various parts of the image, showing that Mahavira had entered the path of knowledge. All this was done in the seclusion of the enclosure. Finally the image was placed inside a bucket and covered with clothes and carried away secretly by a ritual assistant (fig. 208). The last act indicated that Mahavira had disappeared in the forest and had undertaken the path of wandering alone as a monk. The image was brought back to the temple where it was installed on a high stool under a tree. On one side of the image a small peacock-feather broom and, on the other, a waterpot were placed (fig. 204). This represented the event of renunciation and monkhood of Mahavira. The next day the image, representing monkhood, was carried on the head by a devotee to the house of a layman who had invited the monk for a meal. The man stopped in front of the house where stood a couple to invite the monk for a meal (fig. 206). They had pots filled with water and covered with coconuts. The image was worshipped by the host couple by uttering the words of invitation and by circumambulating the image three times. Then the image was brought inside the compound and was placed on a high seat. In front of the image were many silver plates filled with food. The worshippers filled up spoons of food and held it in front of the image in the posture of feeding and emptied the spoons in a plate in front of it (fig. 207). The image was then brought back to the temple.

At night, again in seclusion, the pandit placed the image inside an enclosure and in front of it lit a lamp and uttered many *mantras*. This secret ritual was meant to impart knowledge to prepare for the event of enlightenment. On the morning of the next day, a jaina *guru* performed the most crucial ceremony of opening of the eyes (fig. 210). This indicated the opening of the eyes and enlightenment of Mahavira. The image was placed on top of tapering towered structure, *samavasarana*, the divine preaching hall created by the gods for the preaching of the *tirthankara* immediately after his enlightenment (fig. 209). This also represented the first sermon to the universe.

On the last day, the event of *nirvana* was commemorated. In the early morning the pandit cleaned a patch of ground, drew a *svastika* on it and placed a marble tile over it. On the tile, he constructed a miniature pyre from sandalwood pieces which he lit with a burning piece of

camphor (fig. 193). This indicated that Mahavira had attained the final liberation, *nirvana*, and that his material body was cremated. Now the image was placed inside a glass casket placed over a miniature mountain representing *siddha-sila* under three umbrellas (fig. 212).

The most important part of the ritual of idol installation as practised today is the event of enlightenment represented by the act of touching the pin to the eyes to indicate the opening of the eyes. The act of opening of the eyes is also a prescription for the installation of Brahmanic images. Among the Buddhist practices followed in Sri Lanka, enlightenment is indicated by painting the eyeball as a part of the ritual.

The *tirthankara* image which had undergone the ritual of installation thus becomes qualified for worship in the temple. The ritual of opening of the eyes was also performed over the large main image (*mulanayaka*) in the temple.

Monks of the Digambara Sect

There are today less than 100 monks of the Digambara sect in the whole country. These monks are known as *muni* or *muni maharaj*. They are organised in two different *samghas* or groups which are known after the master of the group or *acarya*.

The one who wants to renounce the world on religious grounds, begins to qualify successively for the 11 basic vows. He starts to control his behaviour, to abstain from violence, to practise truth, to abstain from possession and attachment, and to live a life of a celibacy. Thus disciplined over a period of time, a person prepares for renunciation. He approaches an *acarya* or the head of a group of monks and asks his permission for *diksa*, initiation. If the candidate is a grown-up person devoid of bodily faults and has acquired the consent of his nearest relatives—parents or wife—he is given permission to renounce the world. The community gets together in a festive atmosphere. The candidate is dressed as a prince and taken out in a procession in a chariot or on an elephant (figs. 220 to 226). After that his head is shaved and he is offered the monk's attire. He is also given a new name which ends in such compounds as 'sagara', ocean; or 'ananda', joy; for example, 'santisgara', the ocean of peace, or 'vidyananda', joy of knowledge.

Among Digambaras three stages of monkhood can be distinguished. The monks of the first stage are called *ksullaka* and are permitted to wear two white clothes. Those of the second stage are *ellaka* and allowed to wear one loincloth. The monks of the final stage or the *munis* go naked. Also, different degrees of asceticism are expected during these three stages of monkhood. A *ksullaka*, for instance, is allowed to shave his head unlike the monks of the other two stages who have to pluck out the hair. A full monk eats once a day in standing posture, whereas *ksullaka* may eat twice in sitting posture.

Daily Routine of a Digambara Monk

A monk who has renounced the world is without a home and without possessions and therefore moves around completely naked. The only objects he is allowed to carry are a *kamandalu*, water-pot, and a *pichi*, a fly-whisk of peacock feathers. To practise a strict and severe ascetic life, a monk always lives in the company of other monks. Normally a monk gets up before sunrise to carry out his daily routine. In an open field he finds a clean patch of ground devoid of insects, to perform his daily necessities. After washing his hands and feet (a monk is not allowed to take a bath) he comes back to his monastic chamber where he undertakes his daily *samayika* or study of texts and sits in meditation to identify his faults such as negligence in behaviour towards living creatures. After this he goes to a nearby temple to perform *caityavandana* or worship of the *jina*. On return he goes out to beg for food. A monk keeps the thumb and the four fingers of his right hand joined together while resting on his shoulder. This is called *ahara mudra*. If he loses this posture on his way to the host-householder he is not supposed to eat on that day. This way the monk does not rest assured about the pleasure of obtaining food. A Digambara monk eats in standing posture from the hollow of his hands. The standing posture is prescribed because if a monk cannot stand anymore due to old age or illness the body is to be discarded by fasting till death. For eating or drinking he does not use any pots or pans. He eats the prescribed vegetarian food irrespective of preference. After having eaten, the monk goes back to the temple to practise *samayika* for at least 48 minutes in

order to train his mind so that neither pain nor joy may affect him. If he then does not continue his journey on the same day he stays on and his admirers, the lay-community, gather around him to listen to his preaching. Afterwards the monks read together some scriptures or enter into religious discourses.

The monks usually spend the night in a windowless cell near the temples. In summer they sleep on the 'floor', in winter on a flat wooden board, covered with straw only. In case they feel cold they help themselves with *yoga* practices which warm up the body.

A monk should wander around in the dry season. He should not get used to one place, should be without a house and without any attachment. During the four monsoon months, however, he should stay at one place together with his *acarya*, master, because at this time the growth and development of vegetation and insects are rapid. While wandering, a monk is not allowed to use any vehicle or boat. He has to walk barefoot, avoiding big streets where possible. To cross rivers he walks along the bank till he finds a ford where he is able to cross over. But the water should not be deeper than the level of the knees. Also, he is not allowed to swim.

All Digambara *munis* have to pluck out the hair four times a year. This is done mostly in front of the lay-community of the village. First, they rub ashes on their head, then they pluck out the hair in bunches. In case a *muni* is too old or too weak for this, he asks somebody to pull out his hair. Nowadays these tasks are performed by the temple administrators with great pomp. The hair is collected in cups and is auctioned to devotees for high sums. Later it is put in the river.

When a *muni* is sick, he does not eat food or drink any water. Devotees surrounding him sing devotional songs in loud chorus. After his death the body is placed in a sitting posture in a wooden palanquin named *chakdol*. It is then taken around in a procession and cremated on a sandalwood pyre. According to old scriptures, however, the dead body of a *muni* should be put on a river-bank so that it is either washed away by the river or eaten by birds.

Monks and Nuns of the Svetambara sect

The Svetambara sect is divided into a number of sub-divisions, called *gaccha*, which is a community of monks. The various communities are known after their *acarya*, the master. Such an order of monks and nuns is called *samgha* or *samutdya* and is again divided into various *parivars*, i.e., families. The head of each such family is a senior monk or nun. It is advised that the monks and nuns do not move in isolation and therefore the smallest group should at least consist of two monks or three nuns who observe, control and criticize each other. All monks keep a diary in which they note down all wrong thoughts, expressions and actions, like accidental killing of small creatures, sitting under electric lights, etc. Such a diary is sent at the beginning of the monsoon to the *acarya*, who in accordance with the nature of the faults, prescribes penances of various degrees. Seniority of monkhood rather than seniority of age is the criterion for a higher position in the order.

Svetambara monks and nuns, known as *sadhu* and *sadhvi*, wear two white cotton clothes as garments. In addition, they are allowed to use various large wooden pots with strings while begging for food, and also to keep waterpots in their monasteries and to possess a long stick, four different kinds of flywhisks, a small woollen carpet, a thick and a thin shoulder cloth, a cloth to filter water and another one as mouthpiece. They also carry ritual objects, manuscripts, books and writing paraphernalia. Monks and nuns live on food-begging and are not allowed to light a fire and cook food. It is also prohibited for them to take a bath and they are supposed to pluck out their hair twice a year.

DAILY ROUTINE OF SVETAMBARA NUNS, MONKS

In order to sustain the five most important principles, the daily routine of a monk is strictly disciplined through *anuvratas* (vows) which incorporate : not to violate any form of life, not to speak untruth, not to steal, not to possess anything, and to practise celibacy.

As observed in a monastery in Surat, the nuns wake up shortly after 4 o'clock in the morning, wash themselves, say their prayers facing the east or north for 25 breathings, and repent for sins committed during the night. Then they greet their leader who tells them to put the bed in order, remove the dust in the room and to pick

up creatures tenderly with one small fan of pea-cock feather. Then the *namokara mantra* the daily prayer of the Jaina, is said, after which the leader is venerated. The latter in turn greets her teacher installed as *sthapana*, cross-stand. The nuns greet their superior one after the other. After that each nun decides which vow of the day she will keep; for example, to eat food without salt or sugar; not to speak during the day, not to drink anything, etc. The younger nuns once again turn towards their leader and vow that except the natural motion of the eyelids, they would not undertake any activity without her consent. Then they all go to the temple to worship the *jina*. On returning to the monastery or sleeping chambers the nuns repent for all the possible sins; for instance any creature unintentionally killed on the way or wrong thoughts coming to the mind. Then the head-nun allows them to go out to beg for food. But nuns and monks are allowed to beg only in places where there are no pregnant women and no beggars, where no dogs run about, where only strained water is used, and where food is not cooked specially for them. In most cases the nuns eat together from their pots after returning to the monastery. No food is wasted, even the water with which the lacquered wooden pots are cleaned has to be drunk.

After the meal, the nuns may wash their clothes, write letters, read religious books, speak to guests or embroider the *pato*, the cloth with auspicious symbols. About 3 o'clock in the afternoon the bed is again made, dust is removed, insects are collected carefully and removed, and prayers are said. At 4.30 they go out once again to beg for food, for they must eat their evening meal before sunset, as after that they are not allowed to eat or drink anything. After this meal, nuns visit the temple a second time to repent for bad deeds and take a vow that till the next day they will not move beyond 100 steps in any direction.

Monks as well as nuns often go on a pilgrim-age, i.e. they travel to important holy places, where they lodge in *upasrayas* (temples). During the monsoon months, they are supposed to stay in one place. For this they are helped by the community which invites them formally through beautifully painted long invitation scrolls.

A large number of the Svetambara monks and nuns, even after fulfilling these daily rites, find enough leisure time to write important philosophical, historical and poetic works.

To become a Svetambara monk an aspirant has to be at least eight years old and has to have the consent of his parents for doing so. In addition he should not have any bodily defects, should not be in debt or facing a trial, etc. But it is not necessary, however, that he belongs to a jaina family. The person wanting to take *diksa* (renunciation), should get the company of monks or nuns and should live during this time the life of a *brahmacarya* (maintain sexual purity). Young people first go through a preliminary of the actual monk-consecration, which is strengthened later on. The initiate keeps complete fast to prepare himself for the ceremony. He is dressed in beautiful garments and ornaments and is taken out in a chariot or on elephant in procession in which the whole community joins. The initiate may throw coins in all directions in a symbolic gesture indicating ritually the distribution of his wealth. Then his *acharya*, master, plucks out the hair on his head. The initiate is given the monk's robe and a new name which for monks always ends in 'Suri' or 'Vijaya' and he lives in one of the monks' groups. He visits his former family the next day to beg for his first meal.

When monks and nuns have reached the age where their physical existence becomes a burden, they slowly renounce food, i.e., consciously fast till death which is called *Samlekhana*. During this period the dying monk is surrounded by members of the community who observe him constantly, but refuse to give him any food or water and make clear to him how useless his longings are, as his soul now finally will leave the decaying body. The dead body is dressed in fresh clothes and is tied on a bier and carried in a large procession through the streets with great pomp and joy. The dead body is put down in the evening in a crescent-shaped wooden boat and burnt with large quantities of ghee. It is said that the monk has crossed the ocean of life.

PLATES

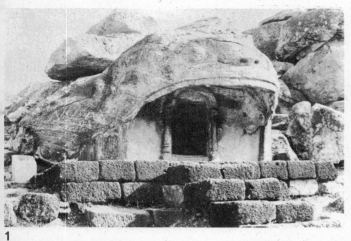

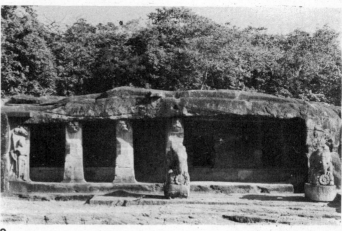

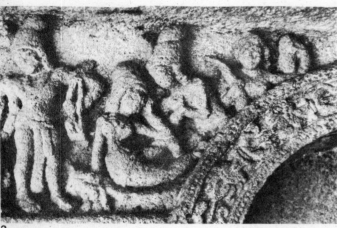

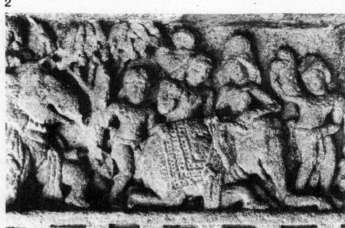

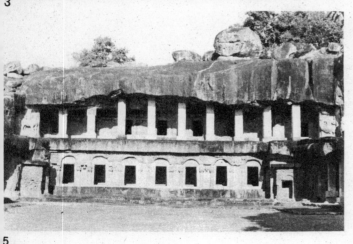

1

2

3

4

5

6

fig. 1 : Monastic chamber in the form of a tiger-head, Udayagiri, Orissa, 1st cent. B.C.

fig. 2 : Monastery at Hathigumpha, Udayagiri, Orissa, 1st cent. B.C.

fig. 3—4 : Relief carvings on the outer walls of Hathi gumpha, Udayagiri, Orissa, 1st cent. B.C.

fig. 5 : A large two-storeyed monastic cave at Rani gumpha, Udayagiri, Orissa, 1st cent. of the Christian era.

figs. 6—8 : Relief carvings depicting war and hunting scenes at Ranigumpha, Udayagiri, Orissa, end of 1st cent. A.D.

7

8

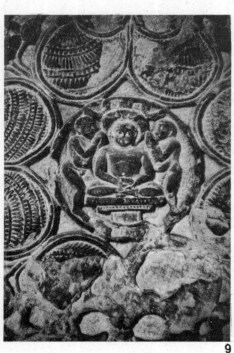

9

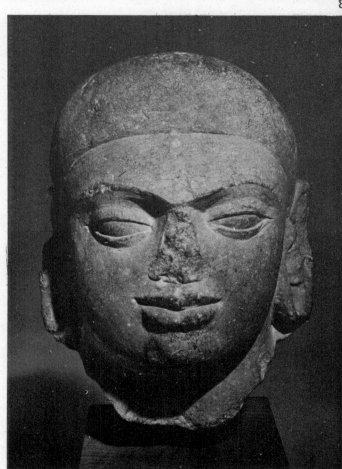

10

fig. 9 : Detail of an ayagapata, votive-tablet, showing
Parsvanatha being worshipped by two naked monks
first cent. A.D., Mathura, now in Lucknow Museum.

fig. 10 : Head of a tirthankara, Kushana style, Mathura,
first cent. A.D. Collection von der Heydt, Museum
Rietberg Zurich. Foto : Wettstein/Kauf.

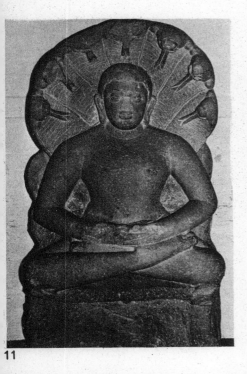

11

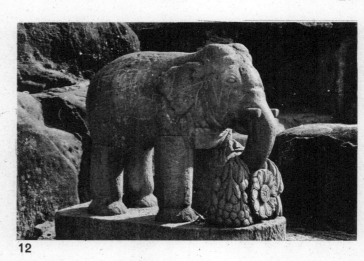

12

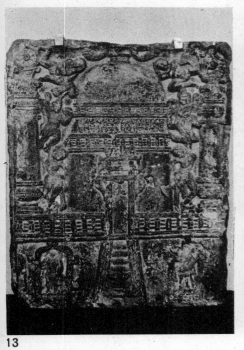

13

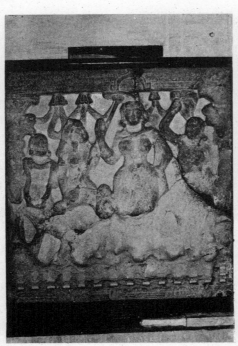

14

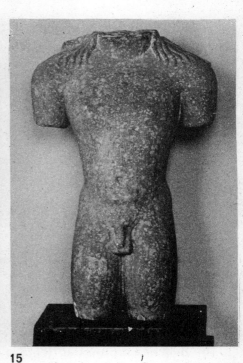

15

fig. 11 : Seven-hooded Parsvanatha in padmasana-posture, Kushana Style, Mathura, now in Lucknow Museum.

fig. 12 : A figure of an elephant with lotus-creeper standing as an auspicious symbol outside Hathigumpha, Udayagiri, Orissa, first cent. B.C.

fig. 13 : Votive-tablet, ayagapata, with representation of a three-tiered stupa and a torana, gateway. Mathura,

first cent. A.D. Mathura Museum.

fig. 14 : Ayagapata or votive-tablet of Aryavati with companions, Mathura, c. A.D. 300, now in Lucknow Museum.

fig. 15 : Torso of Rsabhanatha with long locks of hair hanging on the shoulders, from Kankali mound, Mathura, first cent. A.D., Mathura Museum.

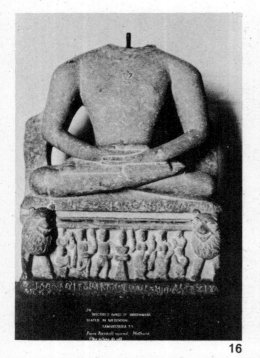

16

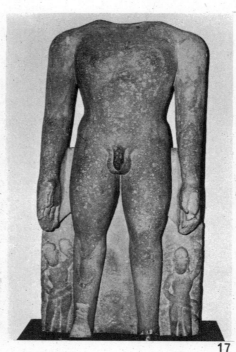

17

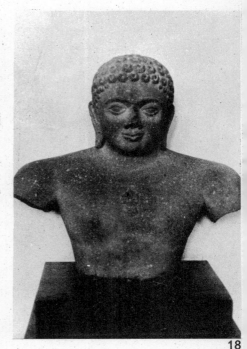

18

19

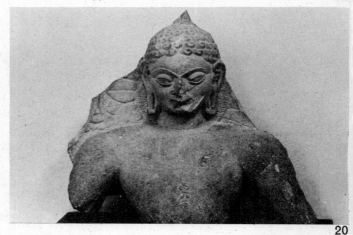

20

fig. 16 : Inscribed image of Mahavira seated in medi
tation. The pedestal shows worshippers paying homage
to a dharmacakra, placed on a pedestal. Kushana style,
Mathura, Mathura Museum.

fig. 17 : Torso of a standing tirthankara, early Gupta
style. Mathura, Mathura Museum.

fig. 18 : Bust of a tirthankara, Gupta style, Mathura,
Mathura Museum.

fig. 19 : Upper half of an ayagapata, votive-tablet,
showing a seated tirthankara flanked by worshippers.
Other symbols like triratna, dharmacakra, a pair of fish
etc. are also seen. Kushana style, first cent. A.D.,
Mathura Museum.

fig. 20 : Bust of a tirthankara, with fragment of an
ornate halo, Kushana style, Mathura, Mathura Museum.

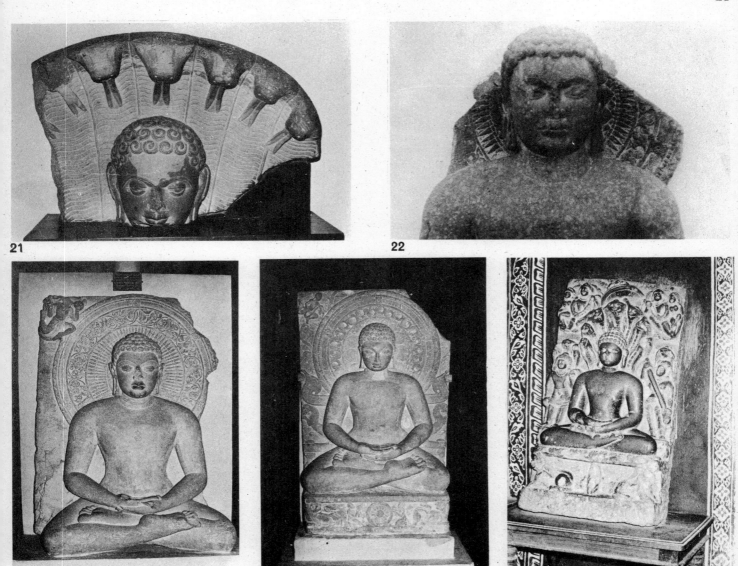

21 22

23 24 25

fig 21 : Fragment of the head of Parsvanatha, Kushana style, Mathura, second cent. A.D., Mathura Museum.

fig. 22 : Detail of a standing tirthankara with fragment of an ornate halo, late Kushana style, Mathura, Mathura Museum.

fig. 23 : Seated tirthankara with an ornate halo and a flying figure or divine worshipper, Gupta style, Mathura, 5th cent. A.D., Lucknow Museum.

fig. 24 : Seated tirthankara with a pedestal containing a frontal dharmacakra flanked by two worshippers. Gupta style, Mathura, c. 5th cent., Lucknow Museum.

fig. 25 : Seated Parsvanatha shown as being protected by nagas and naginis against the attack of Meghamalin, the demon. Post-Gupta style, Jain temple in Alwar, Rajasthan.

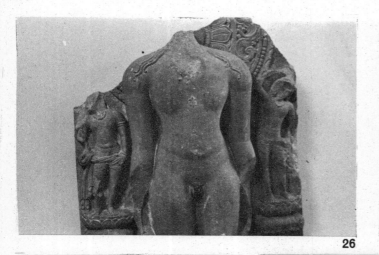

26

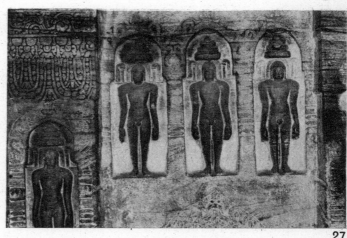

27

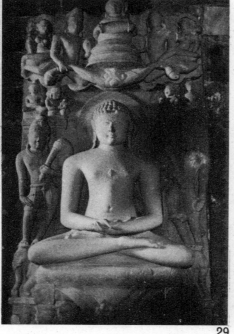

28

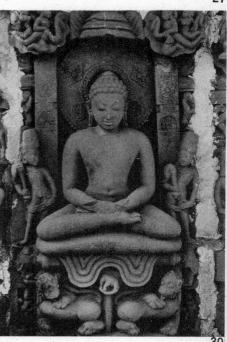

29

30

fig. 26 : Torso of Rsabhanatha with attendant figures standing on lotus-pedestal, Kushana style, probably first cent. A.D., Kankali mound, Mathura, Mathura Museum.

fig. 27 : Tirthankara images in kayotsarga, standing in meditation in jain cave IV, Badami, 7th cent. A.D.

fig. 28 : Rsabhanatha with attendants. The pedestal showing the rim of a dharmacakra flanked by two lions. The corner shows his yaksa and the right one his yaksini. About 10th cent , Lucknow Museum.

fig. 29 : The figure of a tirthankara, surrounded by chauri-bearers, other divine attendants, musicians and the divine umbrellas. Deogarh fort, temple 20, c. 10th cent., Lalitpur dist. U.P.

fig. 30 : Tirthankara Ajitanatha, recognisable through his elephant vehicle depicted on the pedestal. Deogarh fort, temple 13, c. 10th cent., Lalitpur dist., U.P.

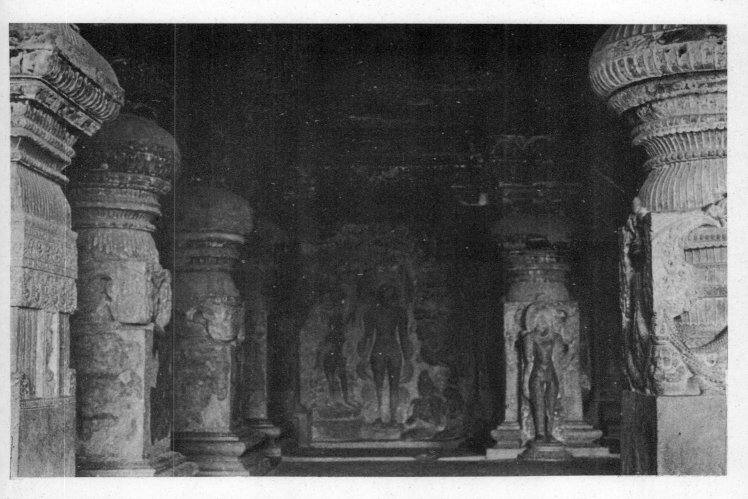

fig. 31 : Large jainistic cave-temple showing in the background a relief of Parsvanatha standing in meditation. Cave 32, Ellora, c. 9th cent. A.D.

32

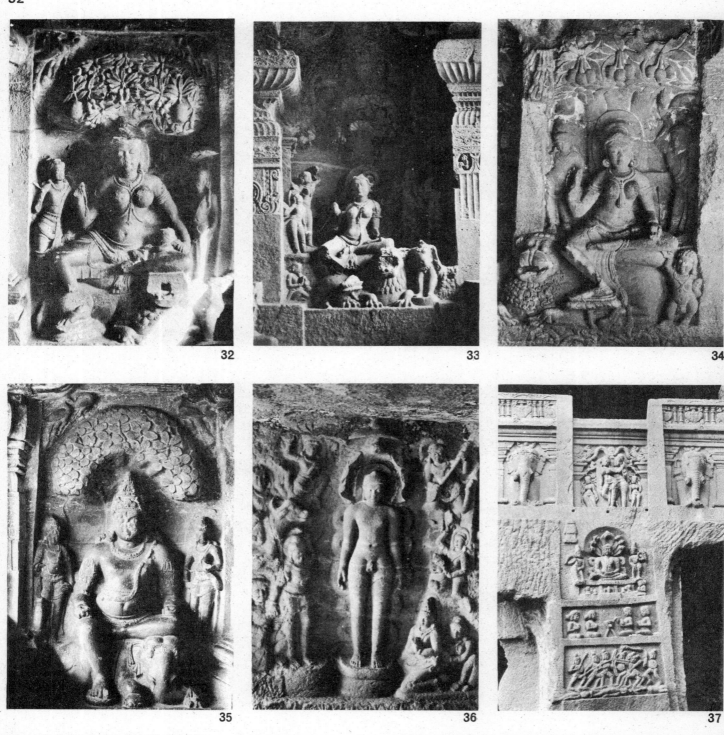

32

33

34

35

36

37

figs. 32-34 : Jaina goddess Ambika seated on her lion vehicle under a mango tree, 9th to 10th cent., Ellora.

fig. 35 : Figure of Matanga, the yaksa of Mahavira, or Indra or Kubera seated under a banyan tree over his elephant vehicle c. 9th cent., Ellora.

fig. 36 : Rescue of meditating Parsvanatha from the attack of Meghamalin, the demon. 9th cent., Ellora.

fig. 37 : Reliefs on the facade of the so-called 'Little Kailasha temple' at Ellora depicting from top : an amorous couple, seated Parsvanatha with chauri-bearers, worshipful monks and nuns, and a fighting scene. c. 9th cent.

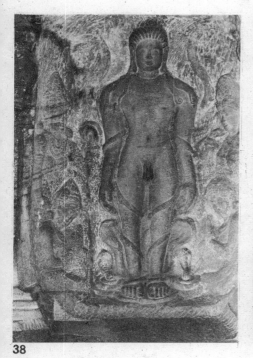

38

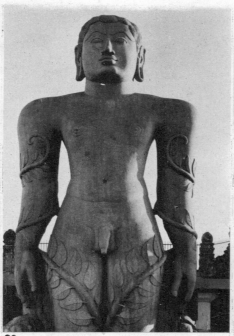

39

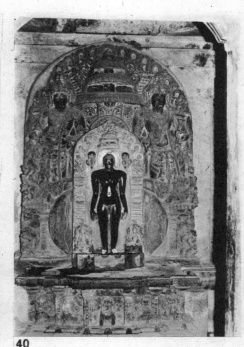

40

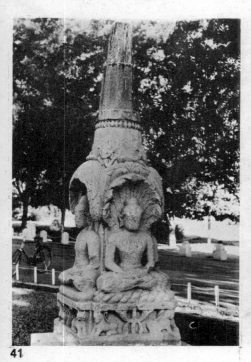

41

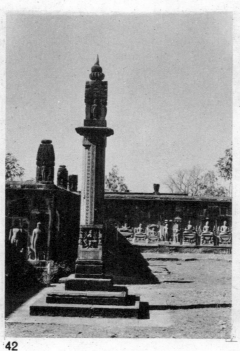

42

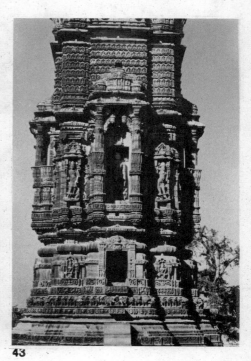

43

fig. 38 : Gommata in meditation, cave IV at Badami, 7th cent. A.D.

fig. 39 : Sculpture of ascetic Gommata, Bahubali, the son of Rsabhanatha, standing in unshaken meditation in kayotsarga, the posture of abandonment of the body. Sravana Belgola, Karnataka, c. 970. A.D.

fig. 40 : The main-shrine in the Digambara temple, Lakkundi, c. 12th cent.

fig. 41 : Caumukha image showing four tirthankaras seated back to back facing four directions. Tekanpur park, near Gwalior, M P., c. 10th cent. A.D.

fig. 42 : A manastambha or pillar of glory showing a fourfold image in the crown and a figure of a yaksi in the base. Deogarh fort, Lalitpur dist., U.P.

fig. 43 : Kirtistambha, the pillar of glory at Chittorgarh, Rajasthan, reconstructed in parts. 12th to 15th cent. A.D.

34

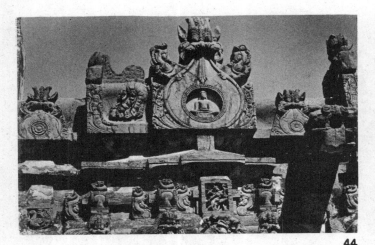

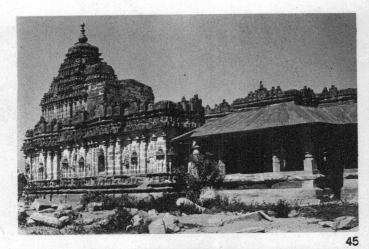

44

45

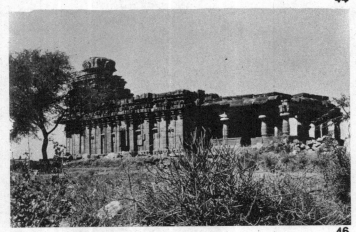

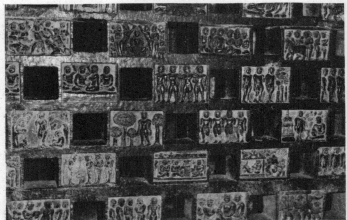

46

47

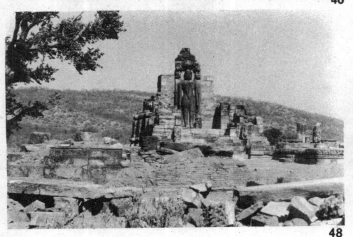

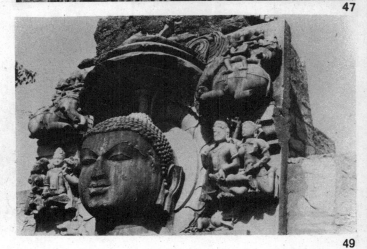

48

49

figs. 44-45 : Digambara temples, Lakkundi, Karnataka, c. 12th cent. A.D.

fig. 46 : Jaina temple near Pattadakal, Karnataka, 9th cent. A.D.

fig. 47 : Reliefs depicting scenes from the life of monks, on the walls of monastic complex at Candagupta basti, Sravanabelgola, Karnataka

figs. 48-49 : Colossal statue of a tirthankara among the

ruins at Navagaja or Nilakanthesvar near Alwar, Raja sthan, c. 12th cent. A.D.

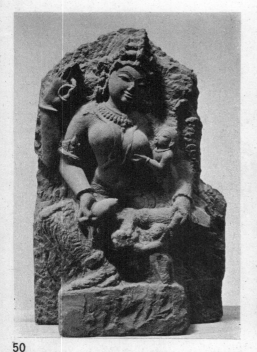

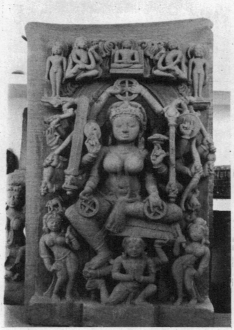

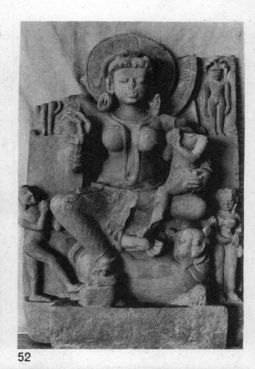

50

51

52

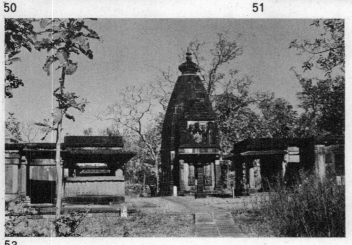

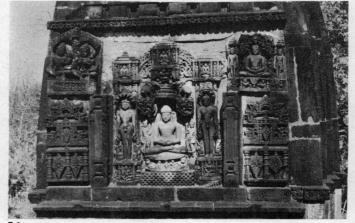

53

54

fig. 50 : An incomplete figure of four-armed Ambika holding her child on her lap. Rajasthan, 11th cent. A.D. Collection Dr A Boner, Museum Rietberg Zurich.

fig 51 : 20-armed Cakresvari seated over a lotus which is carried over the head by her Garuda vehicle. Her two uppermost hands carry a cakra over the head and the two lowermost a cakra in each hand. The rest of the right hands carry a vajra, a goad, a rosary, a disc, a sword, a club and an unclear object. The rest of the eight left hands show a bell, a shield, a staff, a conch, a disc, a bow, an arrow and a snake. Above her head is a seated jina. Temple 12, Deogarh, c. 11th cent. A.D.

fig. 52 : Ambika seated on lion holding her child on the lap. Deogarh, Lalitpur dist., U.P., c. 11th cent. A.D.

figs. 53-55 : Temple and parts of reliefs from ruins at Deogarh fort, Lalitpur dist. U.P., 10th to 12th cent. A.D.

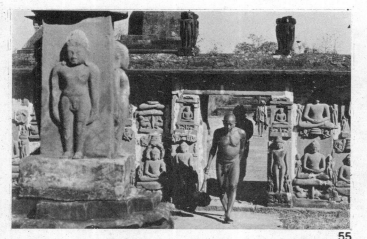

55

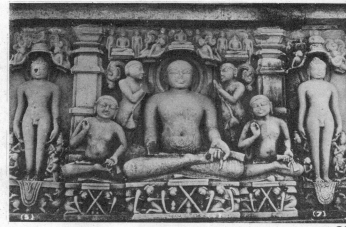

56

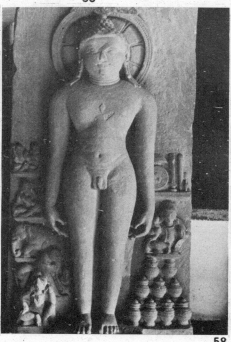

57

58

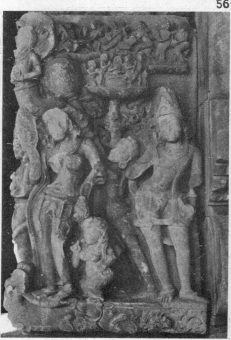

59

fig. 56 : Seated figure of upadhyaya or a teaching monk holding a scripture, flanked by two seated sadhus in the posture of preaching and two standing ones holding their brooms. On the pedestal can be seen sthapana or cross-stands being worshipped by kneeling monks and nuns. Deogarh Fort, Lalitpur dist., U.P. 10th to 12th cent. A.D.

fig. 57 : Probably the parents of a jina seated under a tree with a figure of the jina. Deogarh, Lalitpur dist. U.P., c 11th cent. A.D.

fig. 58 : Cakravartin Bharata, the son of Rsabhanatha, standing in meditation. Navanidhi or the nine pots of wealth are seen on his left. Deogarh, Lalitpur dist., U.P., c. 12th cent.

fig. 59 : Relief on the portal of jaina temple of Maladevi in Gyaraspur, M.P.

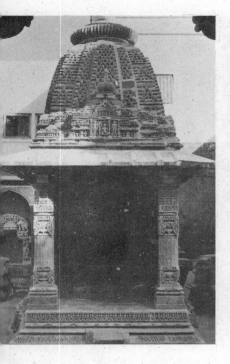

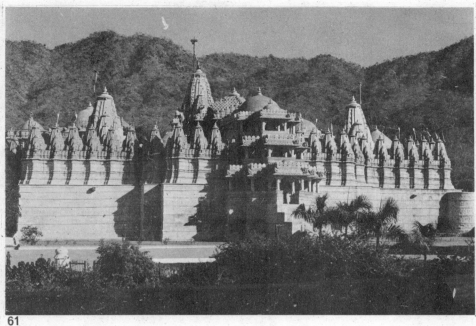

61

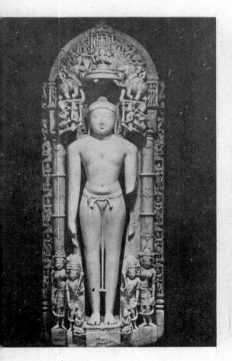

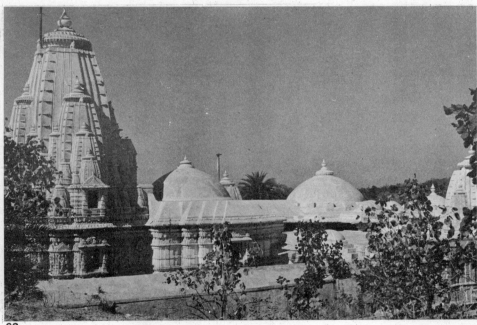

63

fig. 60 : Devakulika, a small side-temple, in the
compound of Mahavira temple, Osian, c. 10th cent. A.D.,
Rajasthan.

fig. 61 : Caturmukha temple at Ranakpur, South
Rajasthan, 1430 A.D.

fig. 62 : Rsabhanatha image from Candravati, South
Rajasthan, 11th cent. A.D. Collection von der Heydt,

Museum Rietberg Zurich.

fig. 63: Kumbharia, Svetambara temple, North Gujarat,
c. 12th cent. (reconstructed).

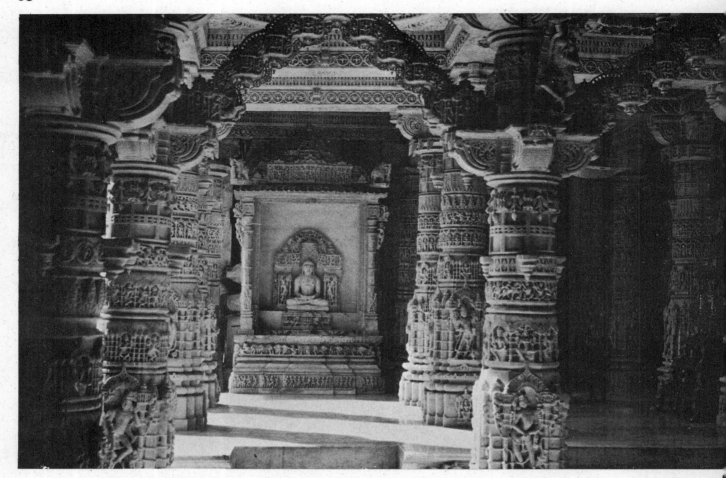

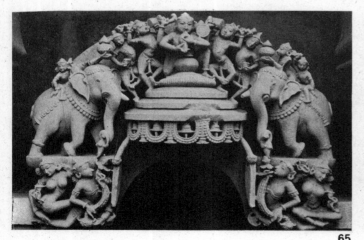

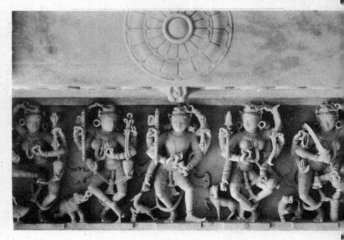

65

fig. 64 : A hall in Vimala Vasahi, Dilwada, Mt. Abu,
South Rajasthan, 1080 A.D.

fig. 65 : A part of the parikara, or the surrounding frame
of a jina image from Osian. c. 9th/10th cent., Rajasthan.

fig. 66 : A panel of gods and goddesses from Vimala
temple, Dilwada, Mt. Abu, Rajasthan, c. 11th cent. A.D.

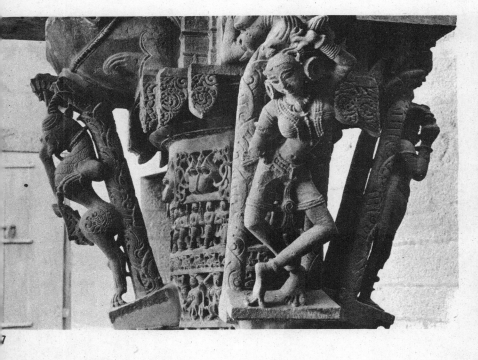

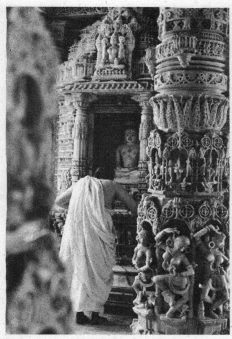

68

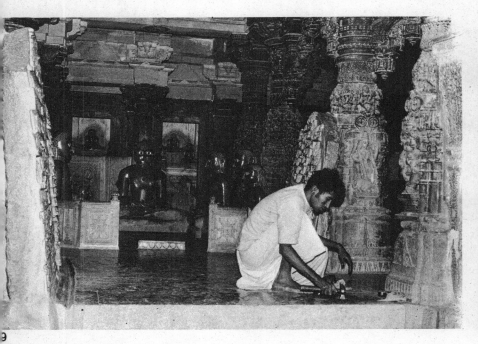

9

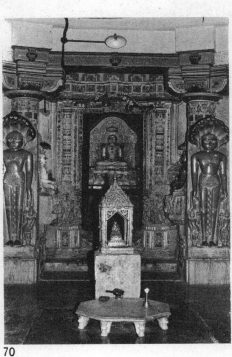

70

g. 67 : Bracket figures on a pillarhead at the entrance
f Parsvanatha temple in Jaisalmer fort, Rajasthan, c.
470 A.D.

g. 68 : A worshipper in Tejapala temple, Dilwada, Mt.
bu, South Rajasthan.

g. 69 : Entrance hall, Parsvanatha temple, Jaisalmer
ort, Rajasthan, 15th cent.

fig. 70 : The main shrine in a Svetambara temple in
Jaisalmer fort, Rajasthan.

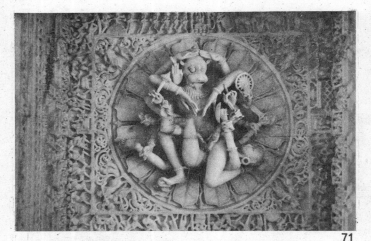

71

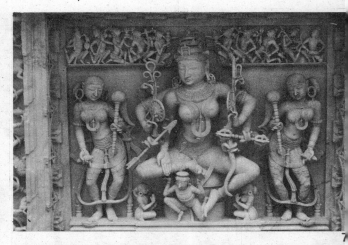

7

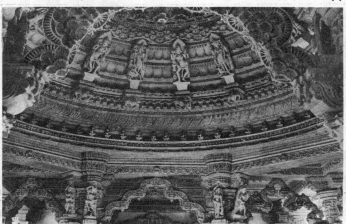

73

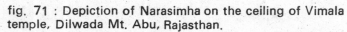

7

fig. 71 : Depiction of Narasimha on the ceiling of Vimala temple, Dilwada Mt. Abu, Rajasthan.

fig. 72 : Goddess Cakresvari carried by her vahana Garuda and flanked by two female chauri-bearers. Vimala temple, Dilwada, Mt. Abu. Rajasthan, c. 11th cent. A.D.

fig. 73 : A part of the ceiling of a mandapa in Vimala temple depicting standing figures of Vidyadevis, Dilwada, Mt. Abu, Rajasthan.

fig. 74 : A ceiling pendant in Vimala temple, Dilwada, Mt. Abu, Rajasthan.

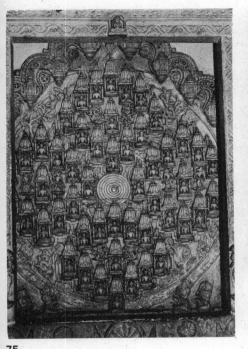

75

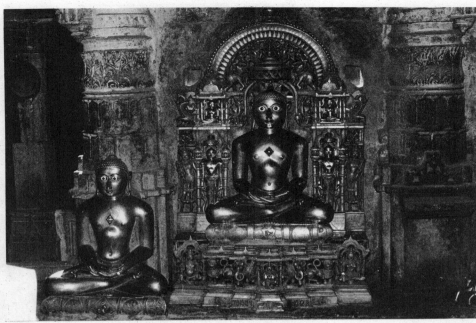

76

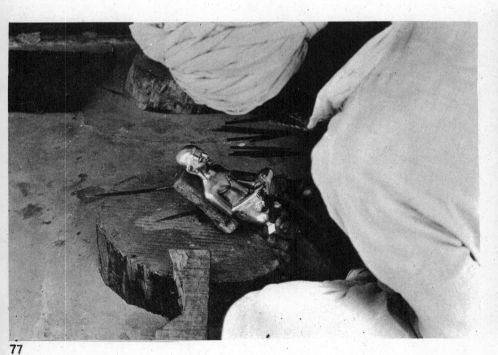

77

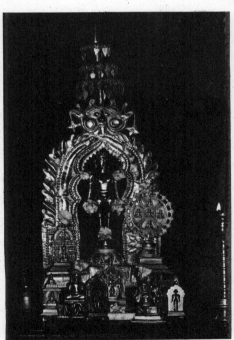

78

fig. 75 : A stone-plaque of 52 temples of the mythical nandisvara-dvipa. Here the temples are depicted in four groups of 13 each. Jaisalmer, Rajasthan, c. 16th cent. A.D.

fig. 76 : Large bronze images, Parsvanatha temple, Jaisalmer, Rajasthan.

fig. 77 : Manufacture of a bronze image. Jaipur, Rajasthan.

fig. 78 : Objects of worship in a Digambara temple at Lakkundi, Karnataka. In addition to the main image more remarkable is the siddhacakra placed on the pedestal and the transparent image of siddha carved through in a metal plaque at the bottom right.

42

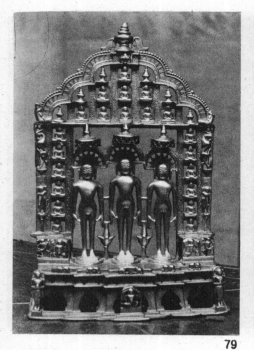

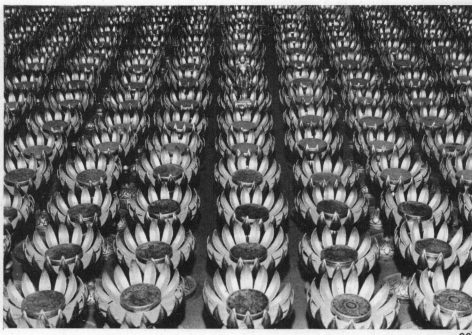

79

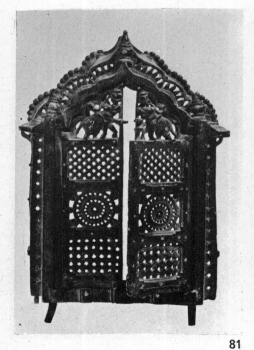

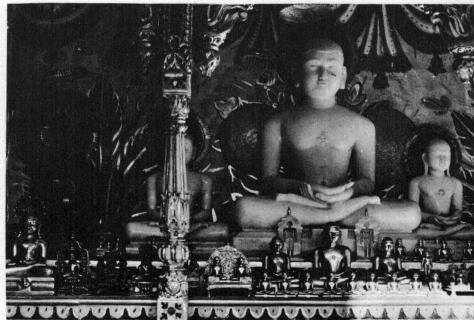

80

81

82

fig. 79 : A metal triple image with 24 tirthankaras. c.
15th cent., Kayastha Mohalla, Digambara temple, Surat.

fig. 80 : A standing jina image on a lotus in a lotus-
pond. Soni Digambara temple, Ajmer, Rajasthan, 19th
cent.

fig. 81 : A miniature house-shrine of bronze with silver-
inlay work. Patan, c. 15th cent. Private collection,
Zurich.

fig. 82 : A Digambara shrine with many small bronze
objects of worship, most of them modern. Near
Deogarh, Lalitpur dist., U.P.

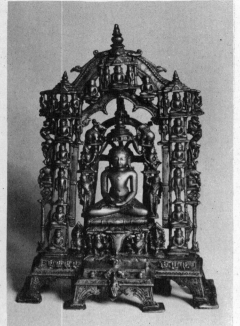

83

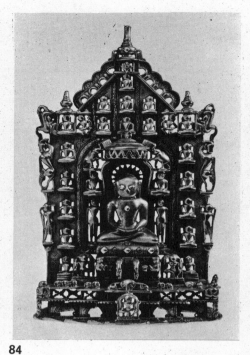

84

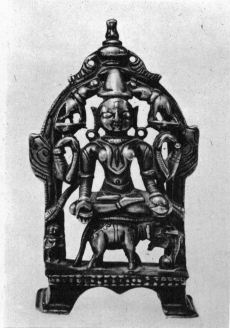

85

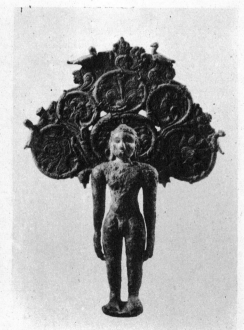

86

87

88

fig. 83 : Bronze with 24 tirthankaras. Dated 1144 A.D., Western India, now in Museum fur Indische Kunst, Berlin.

fig. 84 : Bronze with 24 tirthankaras. 14th cent., North India, private collection, Zurich. Foto : Wettstein/Kauf.

fig. 85 : Jaina goddess Sri or Laksmi seated on an elephant and being lustrated by two elephants. c. 16th cent., private collection, Zurich. Foto : Wettstein/Kauf.

fig. 86 : Bronze shrine of a tirthankara. Medieval period, now in Museum fur Indische Kunst, Berlin.

fig. 87 : Bronze shrine of a tirthankara, South India, c. 17th cent., private collection. Foto : Wettstein/Kauf.

fig. 88 : Tirthankara under a tree. South India, 13th cent., now in Museum fur Indische Kunst, Berlin.

44

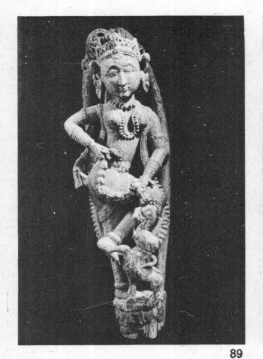

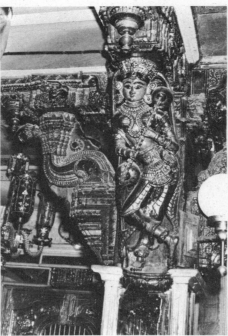

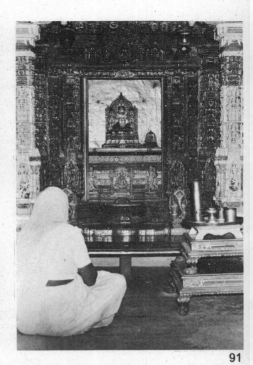

89 90 91

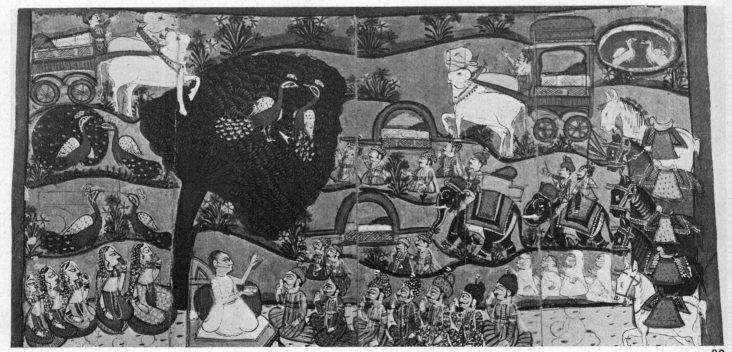

92

fig. 89 : A heavenly maiden and a mythical animal
carved in wood from 17th cent., Ahmedabad, now in
Museum Rietberg Zurich. Foto : Wettstein/Kauf.

fig. 90 : A heavenly musician on the bracket of a pillar
in Kacchi Oswal temple in Bombay, 19th cent.

fig. 91 : A wooden shrine in a Svetambara temple in
Ahmedabad, 18th/19th cent.

fig. 92 : A miniature depicting a Svetambara monk
preaching to a noble audience. Jodhpur, 19th century,
private collection Zurich. Foto : Wettstein/Kauf.

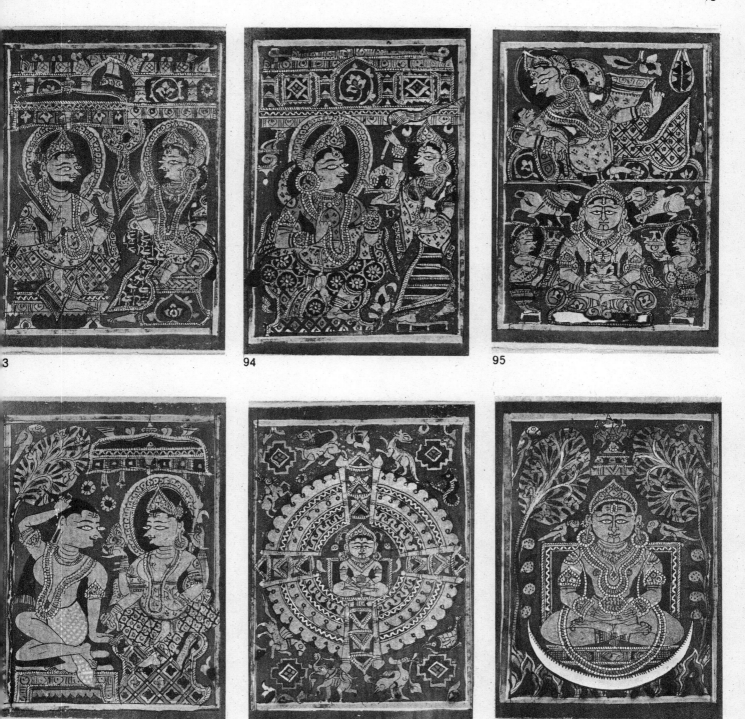

Figs. 93-98 : Miniatures from kalpasutra with scenes from the life of Mahavira : the parents, the mother with an attendant, birth and lustration of Mahavira, renunciation of Mahavira, enlightenment and nirvana of Mahavira. Western India, 16th cent., now in Museum Rietberg Zurich.

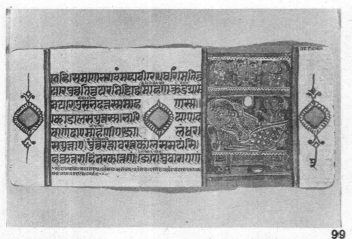

99

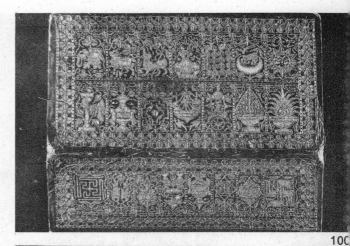

100

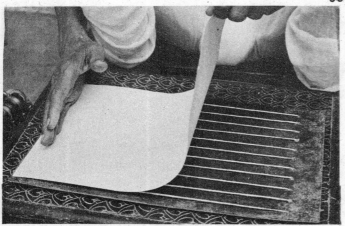

101

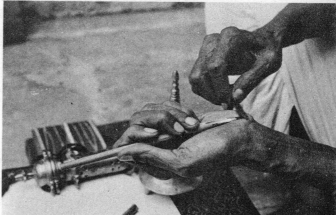

102

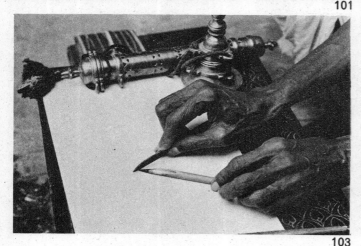

103

104

fig. 99 : A leaf from a manuscript showing the mother of Mahavira expecting a childbirth. 16th cent. Western India, now in Museum Rietberg Zurich. Foto : Zoe Binswanger.

fig. 100 : A gold and silver embroidered book-cover depicting the 14 auspicious dreams and the 8 auspicious marks of the Svetambara Jainas from Patan, Gujarat, now in private collection Zurich Foto : Wettstein/Kauf.

figs. 101-103 : A scribe at work. Preparation of paper and reed-pen. Mandasor, M.P.

fig. 104 : A library attached to a Digambara temple in Alwar, Rajasthan.

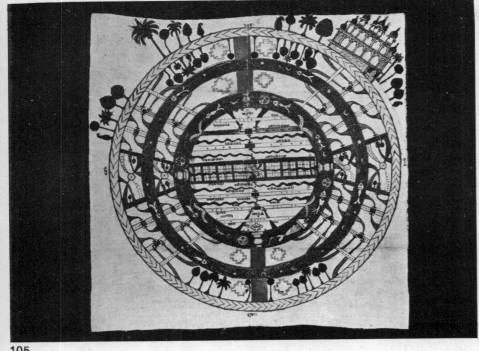

105

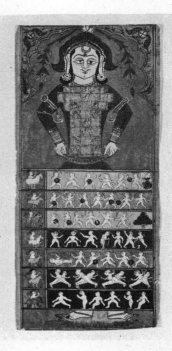

106

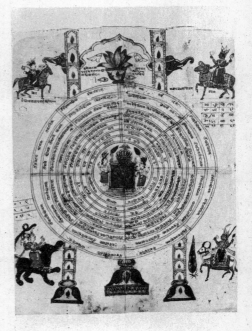

107

fig. 105 : Mythical cosmographical diagram of jambudvipa, the continent which contains Bharatavarsa. Bikaner, Rajasthan, private collection. Foto : Wettstein/Kauf.

fig. 106 : A miniature illustration of the universe in the shape of a man, showing the underworld below the waist, the middle world on the waist, and the upper world above the waist. Suffering of the hell-dwellers can be seen in the sections of the lower world. Rajasthan, 18th cent. private collection. Foto : Wettstein/Kauf.

fig. 107 : A large Parsvanatha yantra painted on cloth. In the four corners can be seen Dikpalas, the direction-gods, in the centre Parsvanatha is shown flanked by two naginis, in the concentric circles the mantra of invocation of Parsvanatha is inscribed. c. 18th cent. Rajasthan. Private collection, West Germany.

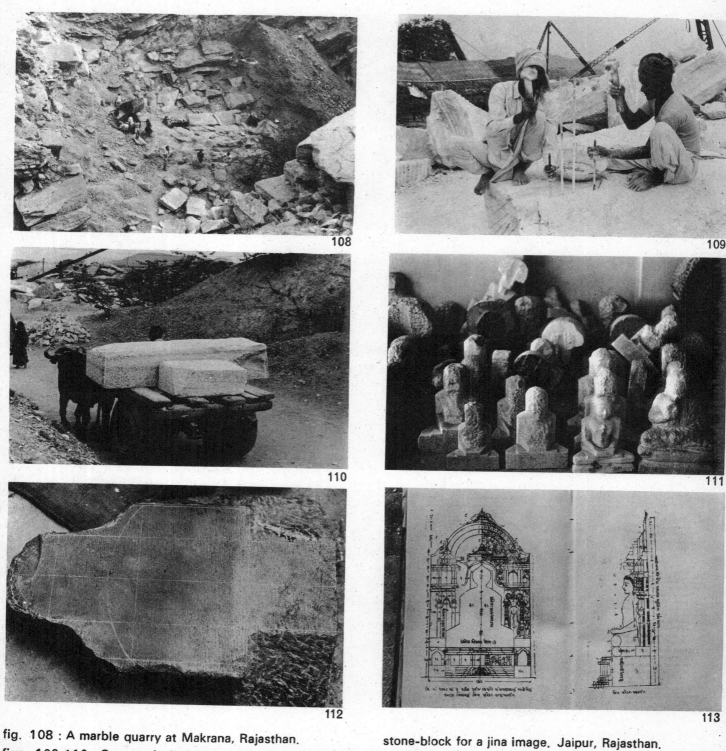

108

109

110

111

112

113

fig. 108 : A marble quarry at Makrana, Rajasthan.

figs. 109-110 : Symmetrical cutting of the blocks of marble and transport to the workshops Makrana, Rajasthan.

fig. 111 : Roughly shaped marble pieces for working out of jina images, in a Jaipur workshop.

fig. 112 : A drawing of proportions on the reverse of a

stone-block for a jina image. Jaipur, Rajasthan.

fig. 113 : A page from a silpa sastra showing the relative proportions of the limbs as well as the outer frame of a jina image.

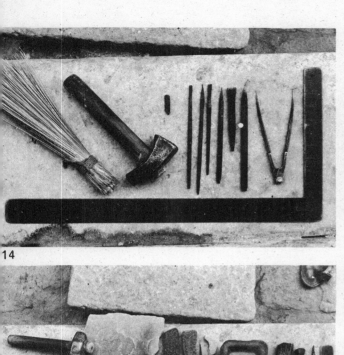

114

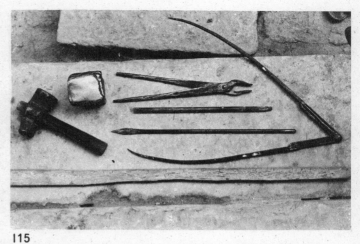

115

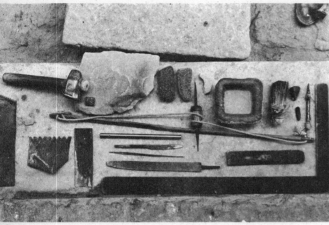

116

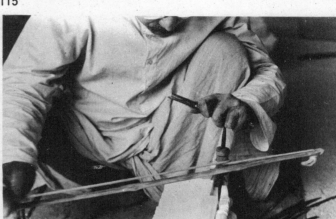

117

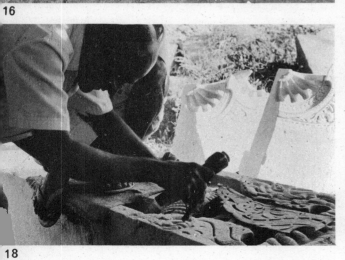

118

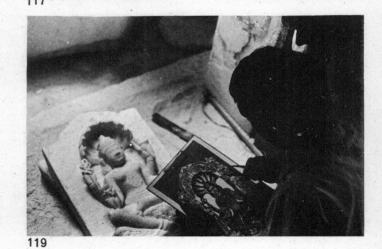

119

Figs. 114-116 : Work-tools of a marble worker in a Jaipur workshop.

Figs. 117-119 : Boring a hole with a drill, using a stencil for transferring ornamental design and comparing proportions with the original model.

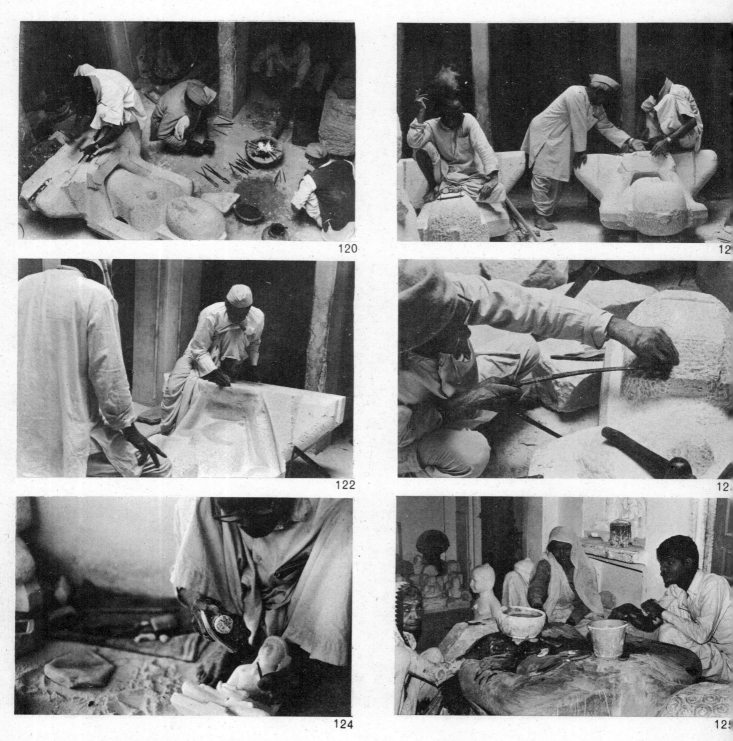

figs. 120-131 : Scenes from a workshop of marble worker with a kiln for reshaping the broken points of the chisels, measurement with a compass, chisel-work, polishing, colouring, filing, sawing, etc. in a Jaipur workshop.

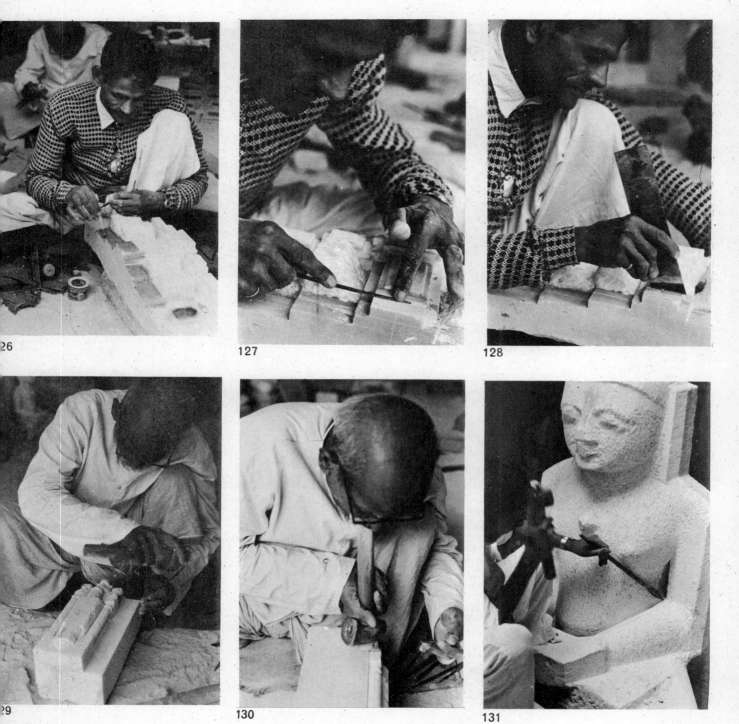

26

127

128

29

130

131

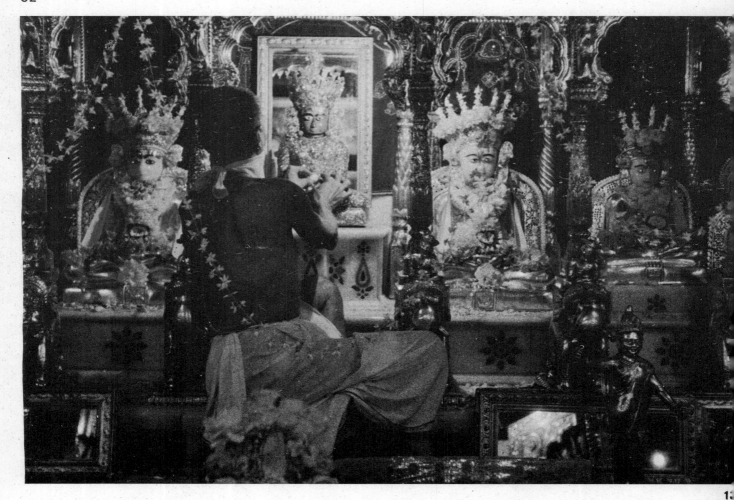

fig. 132 : Evening ritual in Kacchi-Oswal Svetambara
temple in Bombay.

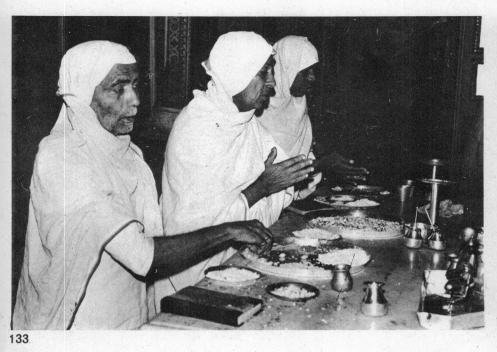

133

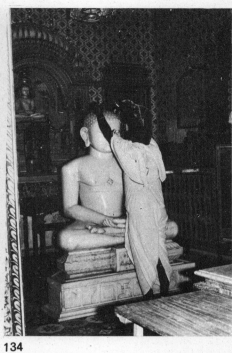

134

figs. 133-134 : Morning ritual in a Digambara temple,
Ajmer, Rajasthan.

54

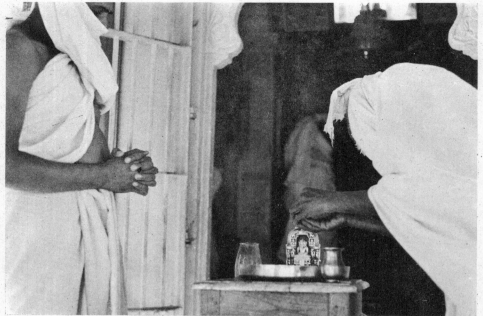

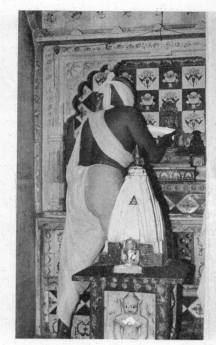

135

136

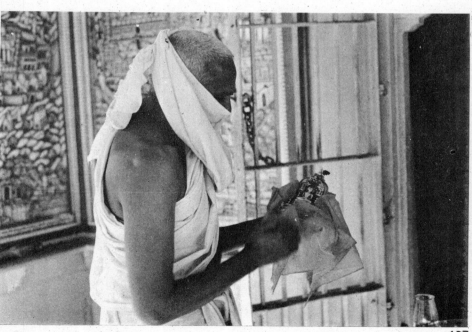

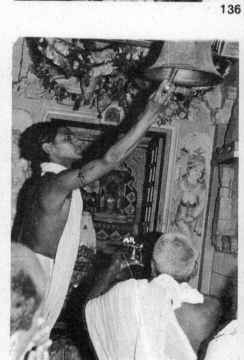

137

138

figs. 135-138 : Morning ritual in a Svetambara temple :
the daily bath, applying of silver-layer, cleaning the
image and ringing the bell.

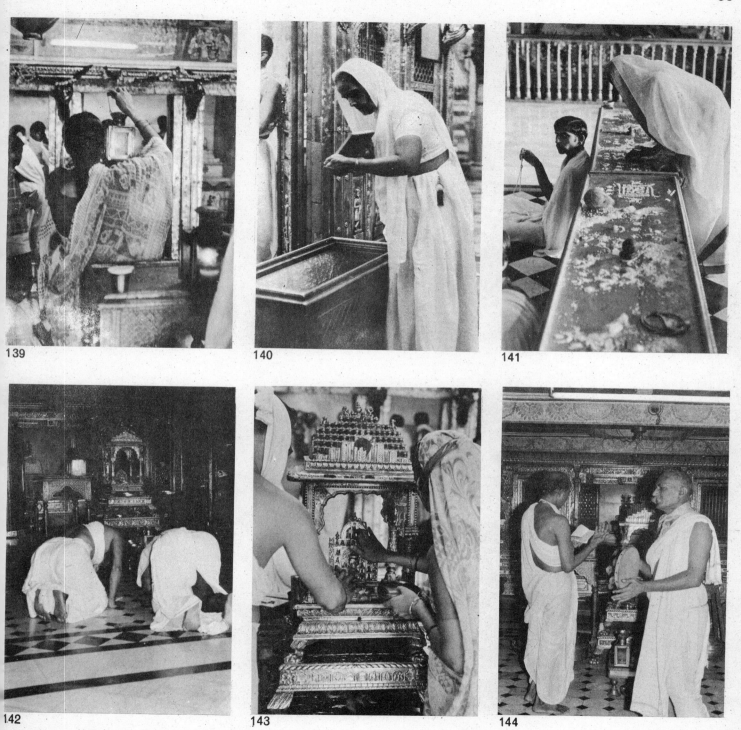

139 140 141

142 143 144

figs. 139-144 · Morning ceremony in Kacchi-Oswal
Svetambara temple in Bombay : darsana with a lamp,
darsana in reflection, offering of rice-grains, kneeling
before the image, application of sandal-paste, singing of
devotional songs.

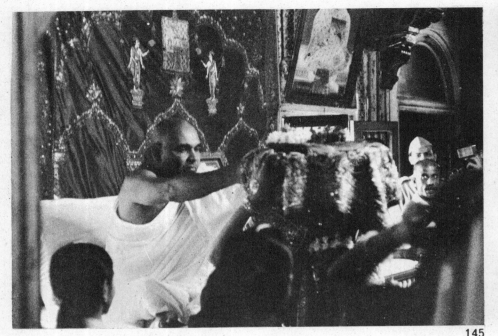

145

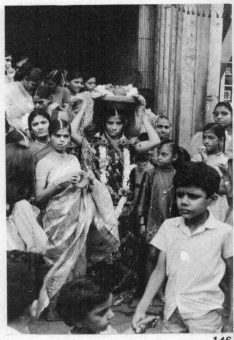

146

147

148

figs. 145-148 : Paryusana festival in a Svetambara
temple : handing over kalpasutra for procession, carrying
the scripture on the head and showing of silver replicas
of the dream images.

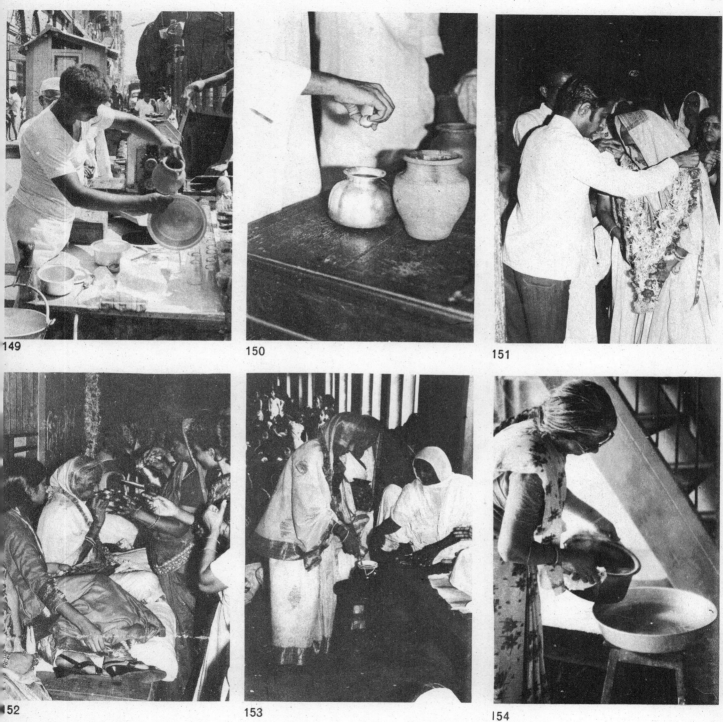

149 150 151

152 153 154

figs. 149-154 : Festival of aksaya-tritiya: cleaning the
sugar-cane-press, ritual measuring of the juice, reception
of a participant breaking the fast by drinking sugar-
cane juice, offering of sugar-cane juice to a nun and
cooling the boiled water for daily use.

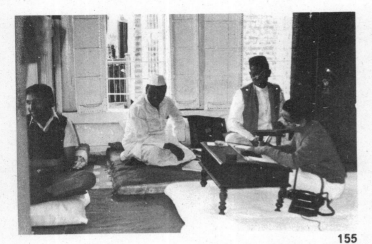

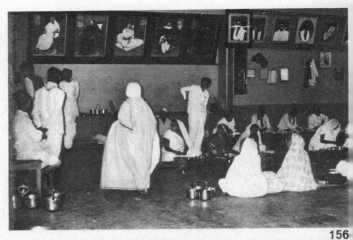

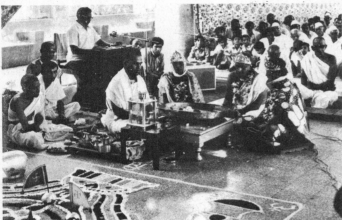

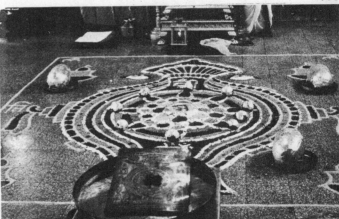

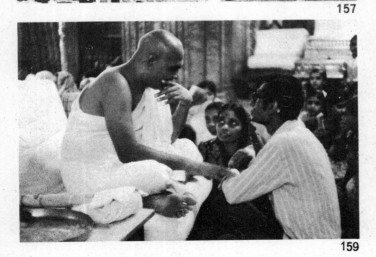

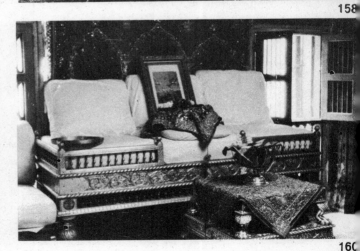

fig. 155 : Shop of a jaina cotton-merchant in Ahmedabad.

fig. 156 : A charitable eating-house for Jainas in Ahmedabad.

figs. 157-158 : Siddhacakra-puja in a Svetambara temple in Bombay.

fig. 159 : A Svetambara monk giving advice to a house-holder.

fig: 160 : Seat of an acarya kept intact in his honour after his death.

161

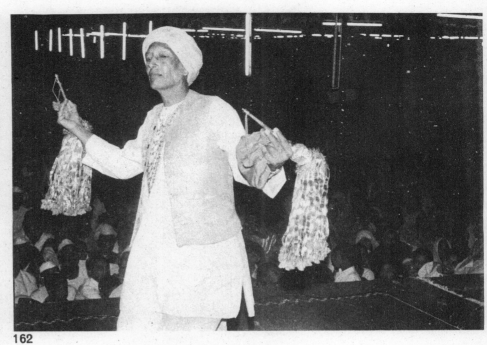

162

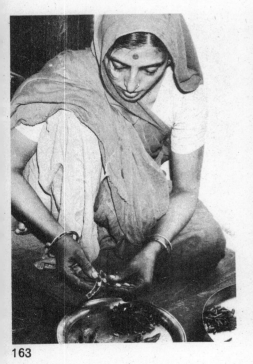

163

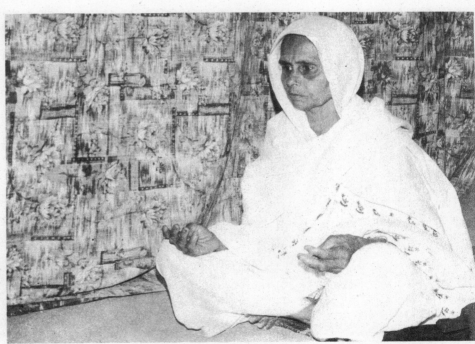

164

fig. 161 : Divali-festival : buying of new account-books at the beginning of New Year.

fig. 162 : A worshipper as temple dancer from Rajasthan.

fig. 163 : A jaina house-wife carefully cleaning the vegetables to avoid killing of insects. Pratapgarh, Rajasthan.

fig. 164 : A Digambara jaina widow in the practice of meditation.

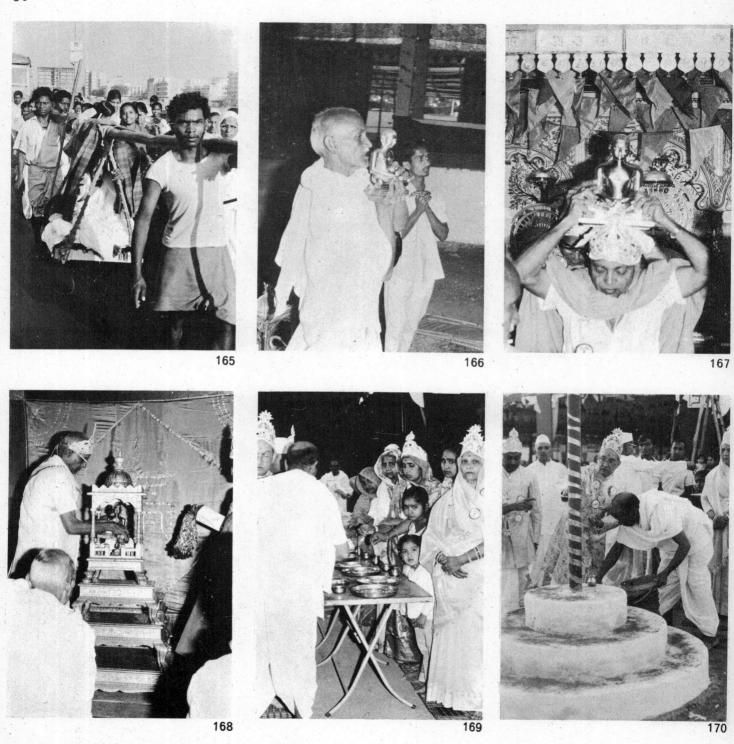

165

166

167

168

169

170

fig. 165 : Pilgrimage in a palanquin, Ahmedabad.

figs. 166-168 : Bringing and placing of an unconsecrated image in a new Mahavira temple in Songarh, Saurashtra.

figs. 169-170 : A ceremony for avoidance of evil and prevalence of auspiciousness.

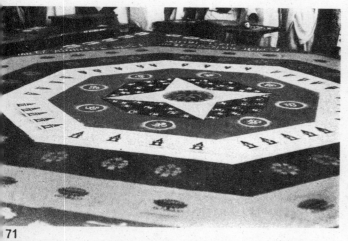

71

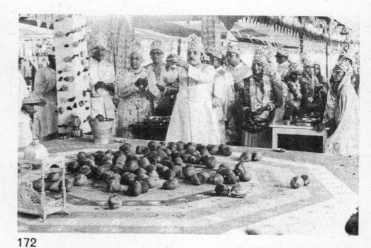

172

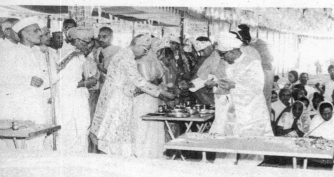

73

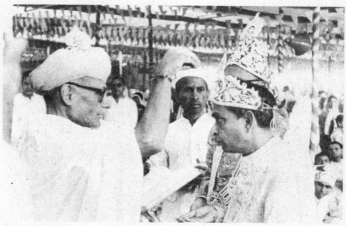

174

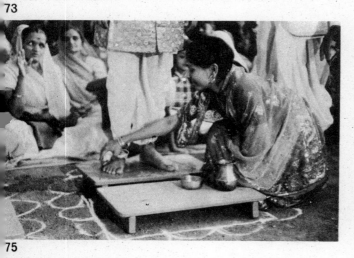

75

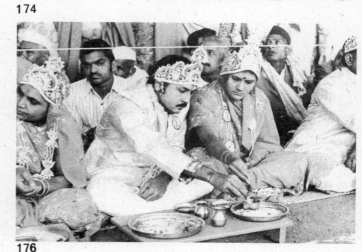

176

Figs. 171-173 : A puja offering to the five great beings of Jainism.

Figs. 174-175 : A worshipper being appointed as Indra for participation in the ceremony of idol installation.

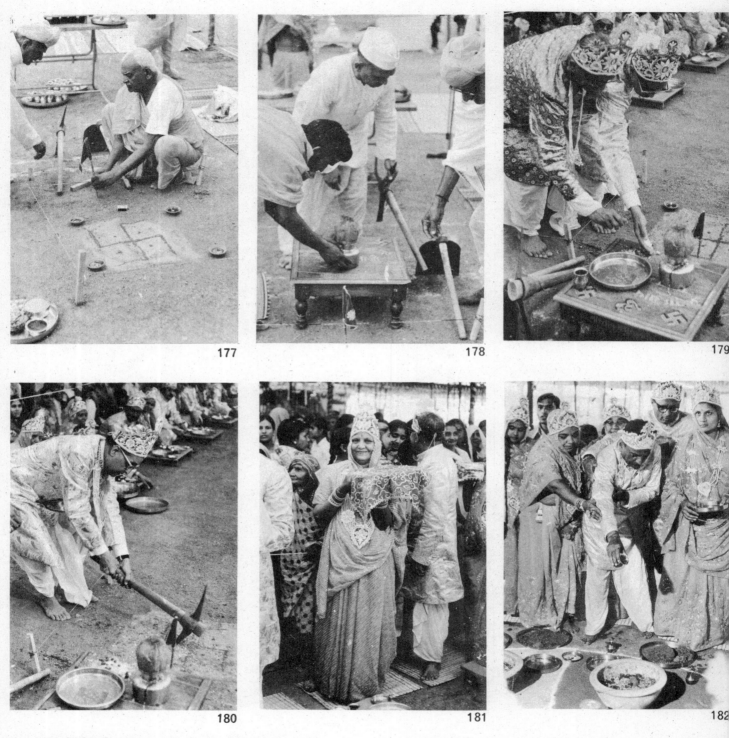

177

178

179

180

181

182

figs.176-183 : Ceremony of digging the earth and
sowing the seeds representing fertility and all-round
prosperity before the birth of a jina.

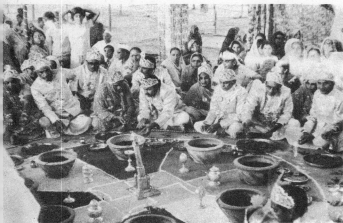

183

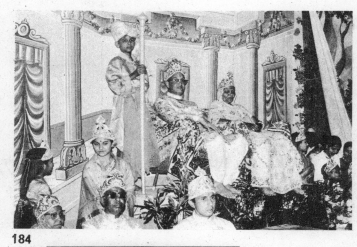

184

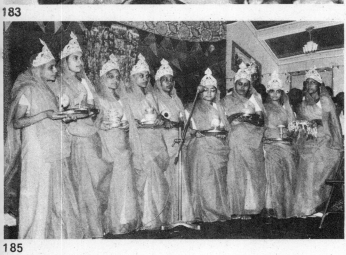

185

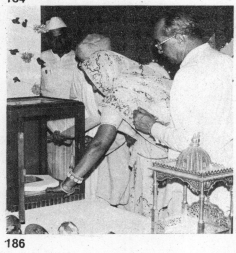

186

figs. 184-185 : Worshippers dressed as parents of the tirthankara and their attendants.

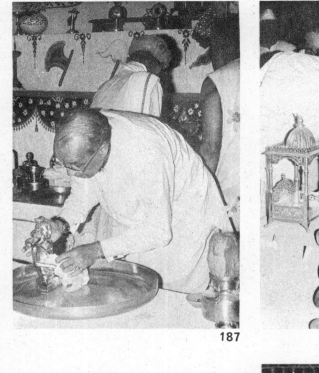

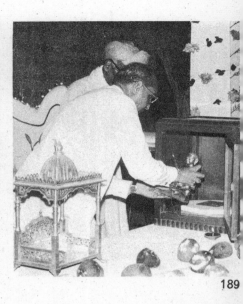

187

188

189

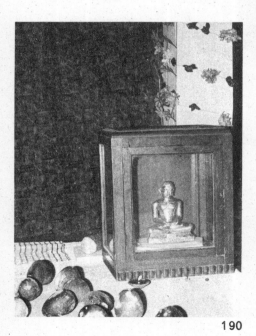

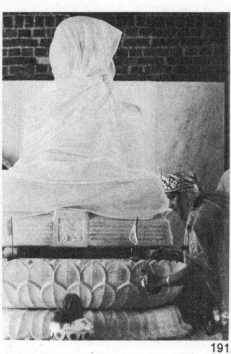

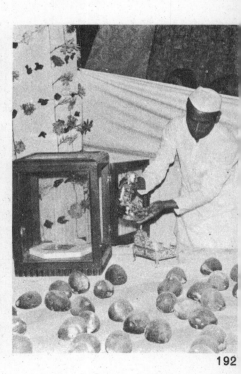

190

191

192

figs. 186-191 : The great event of the conception of the tirthankara. Conception is depicted by placing the image in a glass-casket which represents the womb. However, the large image (fig. 191) is wrapped in white cloth to depict the embryo in the womb.

fig. 192: The great event of the birth of the tirthankara.

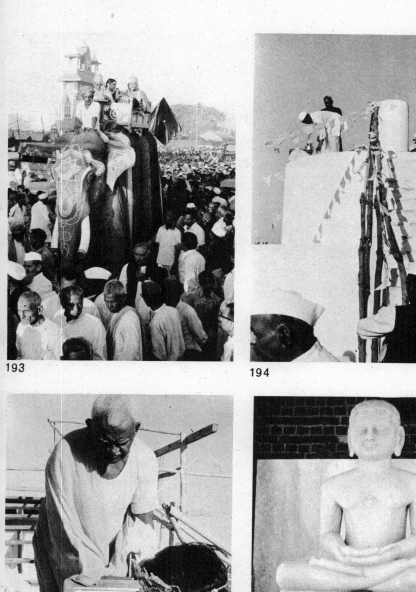

193

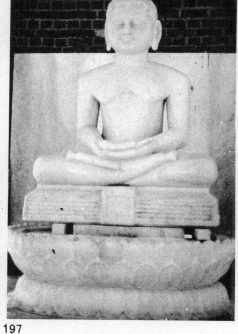

194

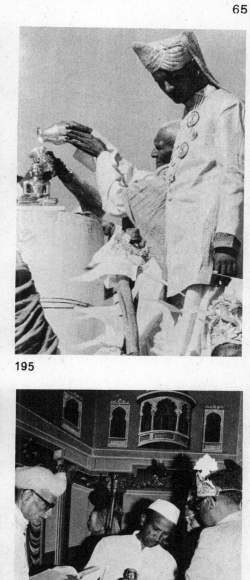

195

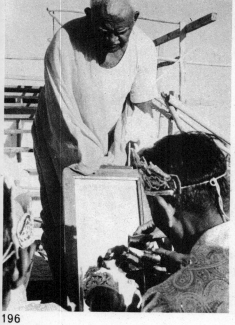

196

197

198

figs. 193-195 : Procession of the image and the first
bath after birth by worshippers dressed as Indras.

fig. 196 : Ritual cleaning of the temple through a bath
given to the reflection of it in a mirror.

fig. 197 : The central image after the first bath.

199

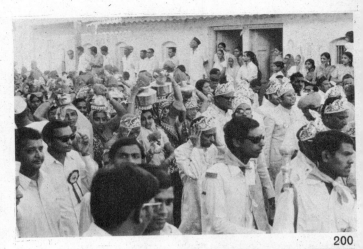

200

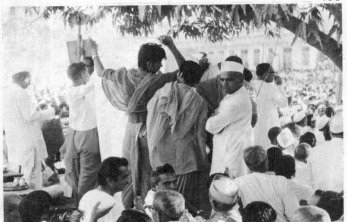

201

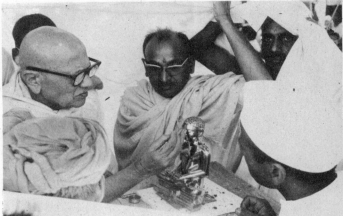

202

203

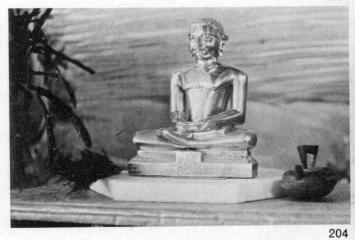

204

figs. 198-199 : Dressing up the image in the garb of a prince.

fig. 200 : A procession celebrating the great event of the birth. Women are carrying auspicious pots on their heads.

figs. 201-203 : The great event of diksa or initiation. Renouncing of the clothes and ornaments in an enclosure under an Asoka tree (fig. 201), inscribing of matrka mantra on various limbs (fig. 202), symbolic removal of the hair (fig. 203).

figs. 204-205 : The Image in the state of a monk accompanied by a broom and a water-pot.

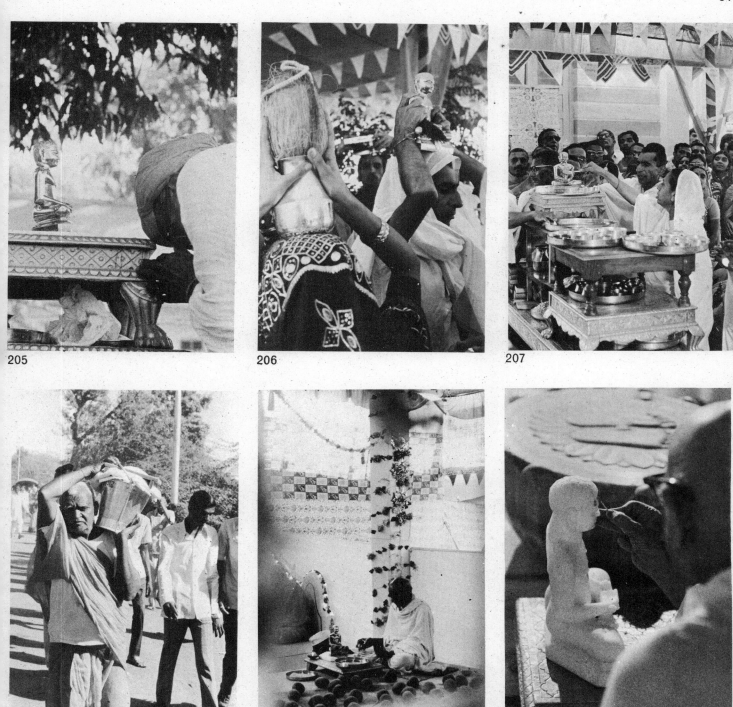

205 206 207

208 209 210

figs. 206-207 : The image now representing Mahavira as monk being given the first meal after renunciation.

fig. 208 : Mahavira goes on secret vihara, wandering in the forest : the image is placed inside a bucket and is being carried away.

fig. 209 : Imparting of enlightenment through chanting of secret mantras in a secluded enclosure at midnight.

fig. 210 : The great event of enlightenment opening of the eyes, nayanonmilana, to symbolise enlightenment.

68

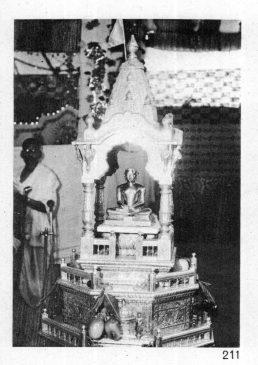 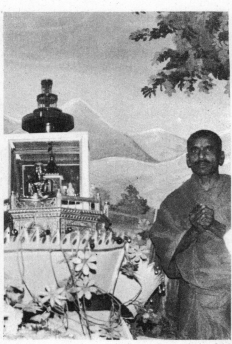 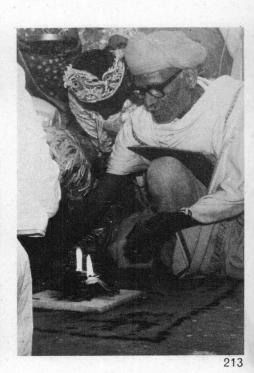

211 212 213

fig: 211: The Enlightened One seated as the world-preacher in the samavasarana, the divine preaching hall.

figs. 212-213 : The great event of nirvana : the image placed under three canopies (fig. 212), symbolic cremation of the material body (fig. 213).

g. 214 : A Digambara nun in meditation. Kishangarh, Rajasthan.

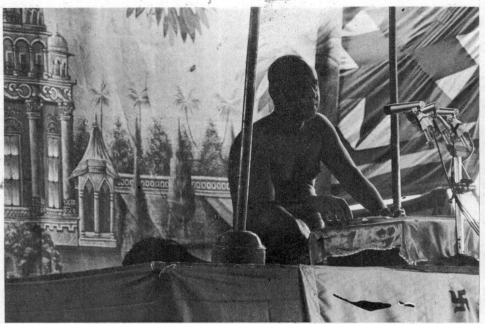

215

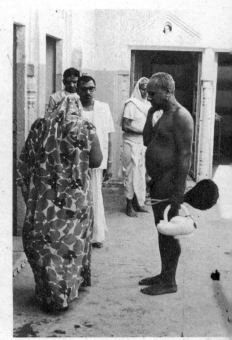

21

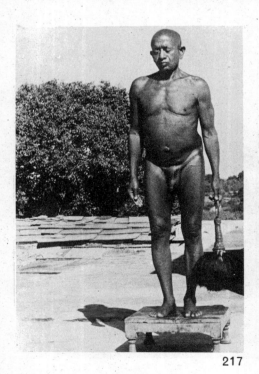

217

218

21

figs. 215-216 : Muni Sri Vidyananda preaching at Alwar, on food-begging tour.

figs. 217-218 : A Digambara monk meditating in kayotsarga, standing, and padmasana, seated posture.

fig. 219 : A wandering Digambara monk, Deogarh, Lalitpur dist., U.P.

71

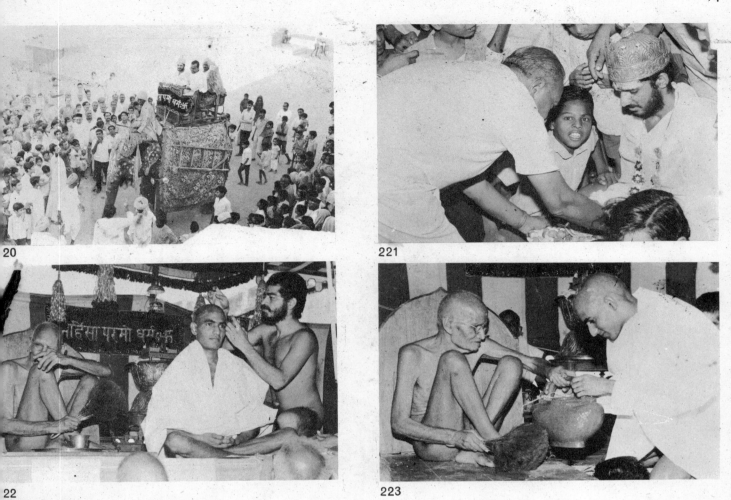

20

221

22

223

Figs. 220-226 : Ceremony of diksa, initiation, for the initial stage of a Digambara monkhood at Nasirabad, Rajasthan. Procession, royal attire, plucking out of hair, handing over of ascetic equipment, procession-chariot, taking part in a ritual, worship of the monk by his parents.

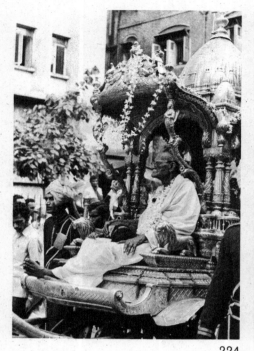

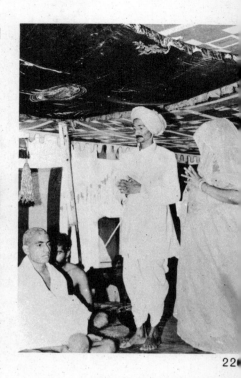

224

225

22

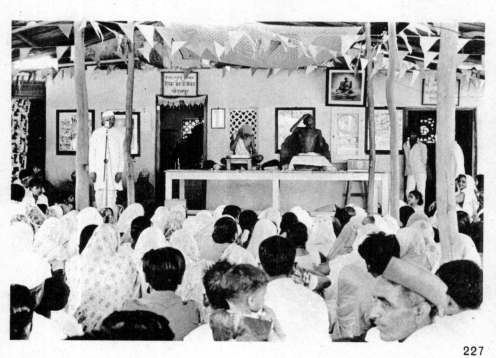

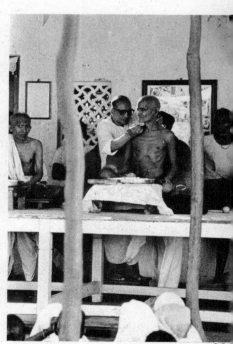

227

228

figs. 227-234 : Ceremony of hair- plucking in a
Digambara temple, Podanpur, near Bombay

229

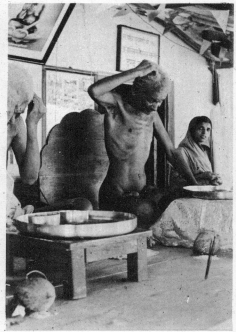

230

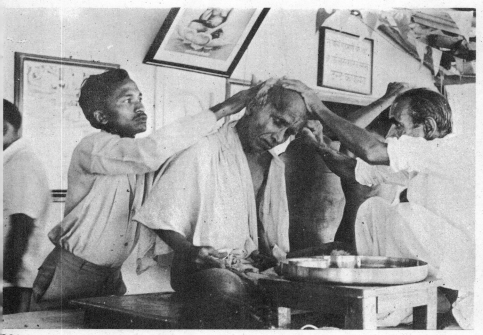

231

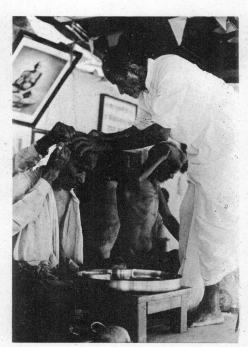

232

74

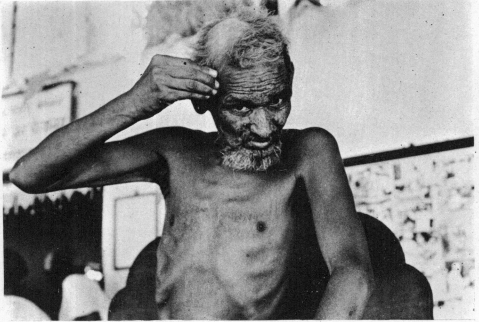
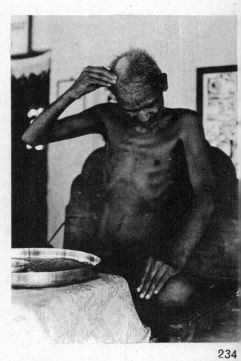

233

234

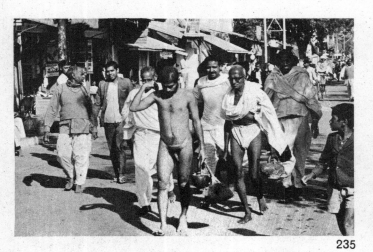

235

236

figs. 235-246 : Food-begging and eating of Digambara
monks at Nasirabad, Rajasthan, and Deogarh, U.P.

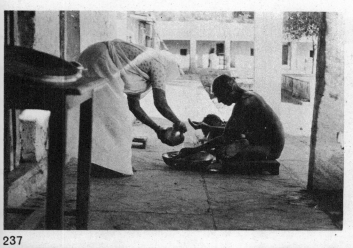

237

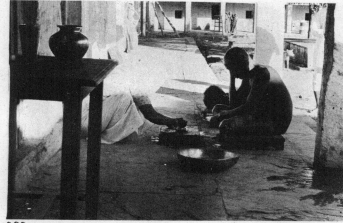

238

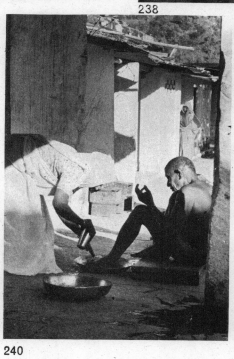

239

240

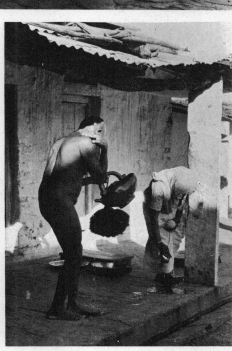

241

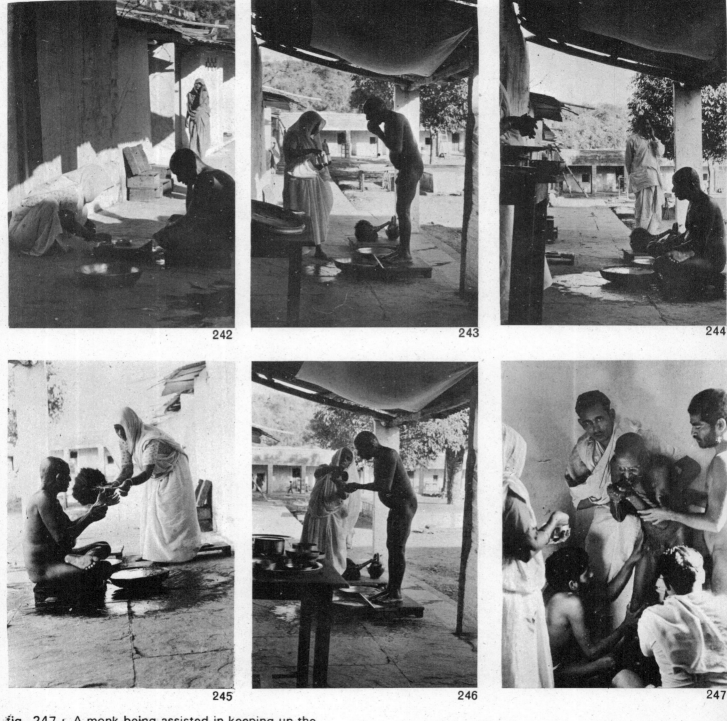

242

243

244

245

246

247

fig. 247 : A monk being assisted in keeping up the prescribed standing posture while eating, Nasirabad, Rajasthan.

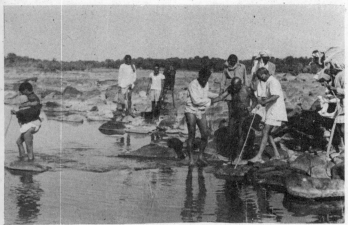

248

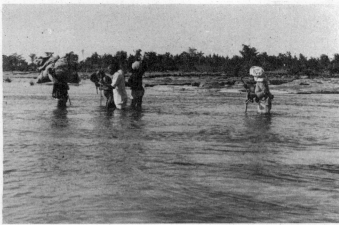

249

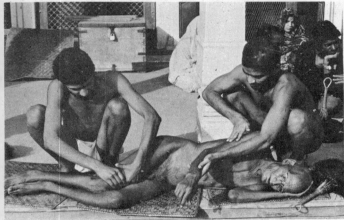

250

251

figs. 248-249: A Digambara monk crossing over a river, use of a boat being prohibited. Deogarh, U.P.

fig. 250 : Junior monks looking after the health of their acarya.

fig. 251 : Cremation of a Svetambara monk on a boat-shaped pyre in Delhi.

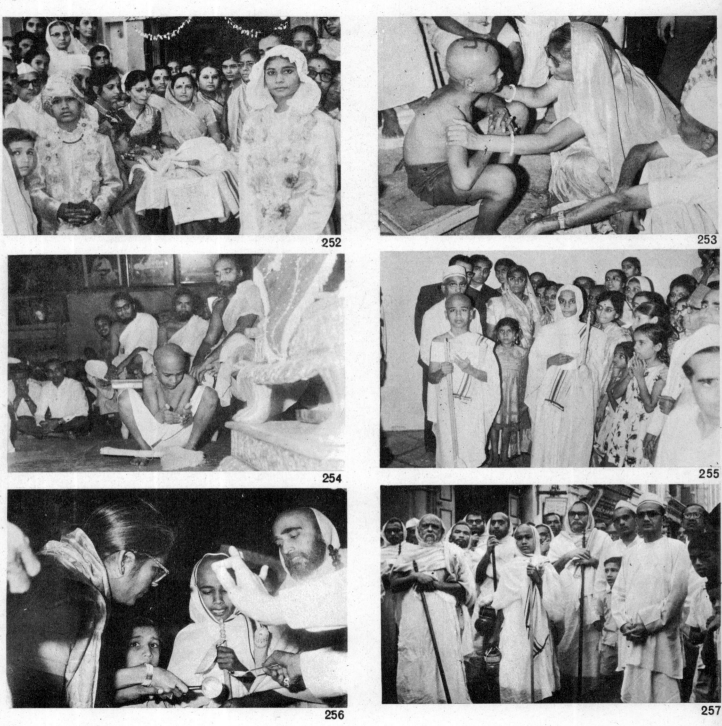

252

253

254

255

256

257

figs. 252-257 : Ceremony of diksa, initiation, of
a Svetambara monk and nun in Surat : Procession of the
child-candidates, advice of the mother, greeting the
acarya, in the ascetic attire, receiving first meal from the
mother, a member of the group of monks.

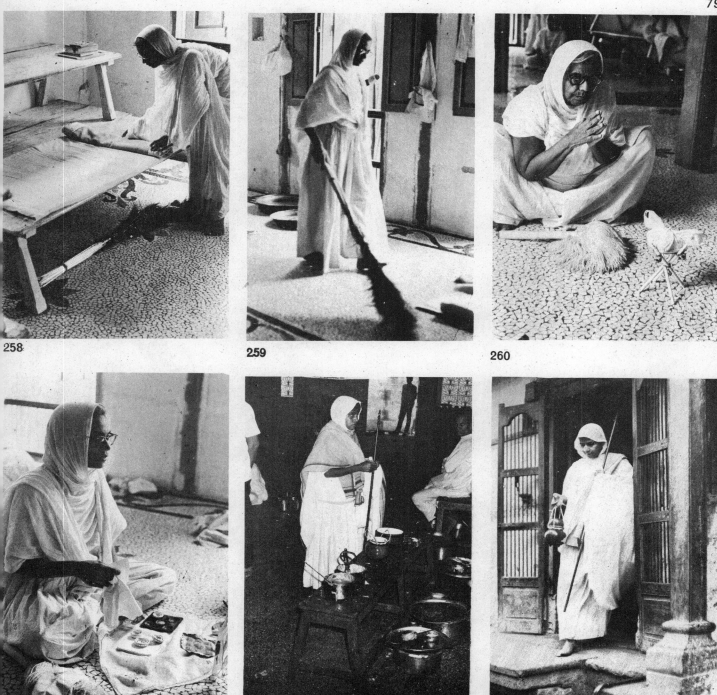

Figs. 258-270 : Daily routine of Svetambara nuns at Surat, Gujarat : winding the bed, cleaning the floor, worship of the acarya, wiping the conch symbols of the five highest beings, begging food, wiping the monastery floor, cleaning the utensils, blessing the worshippers, making the bed, on pilgrimage, preaching in a temple, and wiping the sticks.

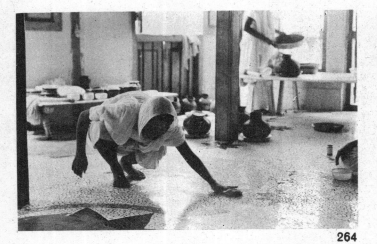

264

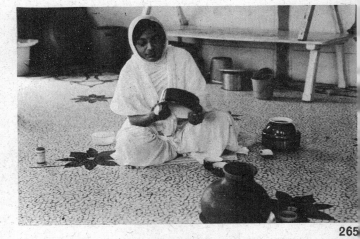

265

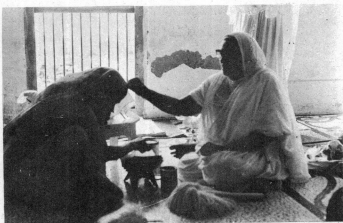

266

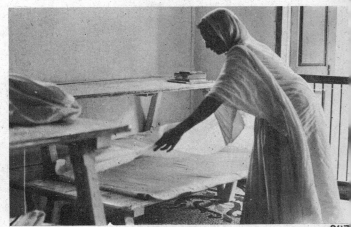

267

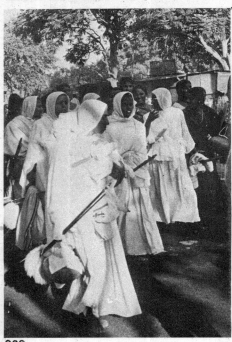

268

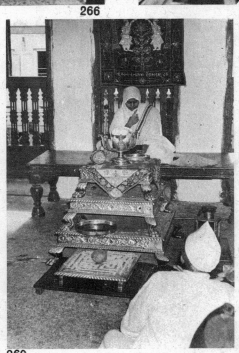

269

270

+91-94262-01439